C O V E R

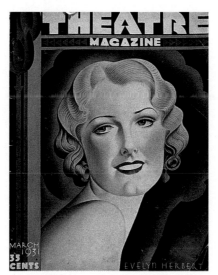

MARCH
1931
35
CENTS

EVELYN HERBERT

S T O R Y

STEVEN HELLER

COVER

THE ART OF AMERICAN MA

CHRONICLE BOOKS

& LOUISE FILI

S T O R Y

GAZINE COVERS 1900-1950

S A N F R A N C I S C O

ACKNOWLEDGEMENTS

The authors are very grateful to Bill LeBlond, our editor at Chronicle Books, for his continued support and encouragement; Leslie Jonath, associate editor, for her hard work and good will; Michael Carabetta, art director, for his direction and suggestions. This project could not have been completed were it not for Leah Lococo's design assistance and Mary Jane Callister and Tonya Hudson's production expertise. Our appreciation also goes to our principal lenders, Mirko Ilic, Paul Rand, and Richard Samuel West (of Periodyssey). Thanks to Diana Edkins at Condé Nast Publications, Jo Mattern at *Fortune Magazine*, Laurel Purcell at *Harper's Bazaar*, Pamela Fiore at *Town and Country*, Richard Stepler at *Popular Science*, and Debra Armstrong Morgan at the Harry Ranson Humanities Research Center at the University of Texas at Austin. And last, but not least, we thank our agent Sarah Jane Freymann of Stepping Stone Literary Agency. — SH & LF

MOTOR AGE

JANURY 1946

A CHILTON
PUBLICATION

ANTI-FREEZE

"A history of American periodicals is a valuable addition to the stock of national intelligence," wrote magazine scholar and historian Frank Luther Mott in 1936. "In the United States magazines have contributed to the democracy of literature without necessarily lowering its tone,

and were invaluable records of contemporaneous history." Mott's thorough

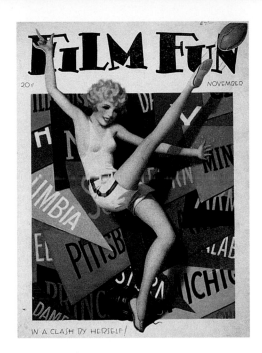

assessment of magazines from 1741 to 1930 in his five-volume *A History of American Magazines* (Cam- bridge, 1936 – 1968) is a testament to a medium that for over two centuries has chronicled the pro- ducts, promoted its heroes, decried its villains, extolled its virtues, and propagated its ideology. Moreover, mag- azines greatly contributed to mass media's influence on the American people. Yet virtually nowhere in this remarkable litany of social, cultural, and political publishing achievement is there any serious discussion of the magazine industry's other principal legacy—its art. Specifically its cover art, which at times has influenced the styles and fash- ions and perpetuated the stereotypes and myths of American life.

The magazine cover is to twentieth-century United States history what cave mark- ings were to prehistoric man, hieroglyphic inscriptions were to the ancient Egyptians, and painting and sculpture were to fourteenth-century Europeans: art, communication, and folklore. Magazine cover art telegraphs as much about the culture in which it was produced

as the specific periodical it represents. Magazine covers are visual representations of the mores, ideals, and the social and cultural values of the nation as filtered through the lens of mass media. Prior to the advent of television, the illustrated magazine cover gave rise to many of America's lasting icons. James Montgomery Flagg's archetypal rendering of Uncle Sam premiered on the cover of *Collier's* before appearing as a U.S. Army recruitment poster; Charles Dana Gibson's "Gibson Girl" and Howard Chandler Christy's "Christy Girl," the most popular female idealizations of the Gilded Age, adorned the covers of *Life* and *Ladies Home Journal;* and Norman Rockwell's picture-perfect vignettes of daily life on *Saturday Evening Post* covers offered a vision of the United States as mythic as any religious tableau.

Magazine covers were designed to entice, allure, and engage. Most soothed the eye with beauty, some tweaked the funny bone with humor, and a few piqued raw emotions. During the world wars, American magazine covers were staunchly patriotic and stridently polemic. Arthur Szyk's monstrous depiction of a bloodthirsty Japanese Emperor Hirohito on the cover of a World War II-era *Collier's* fanned the flames of war, and perpetuated the demonic images of the nation's enemies more efficiently than any government-issued propaganda. In this sense, magazine covers loyally served the national agenda.

The American magazine cover was a museum of the street, a highly visible outlet for painters, illustrators, cartoonists, and graphic designers to exhibit their diverse talents. To be featured on the front of one of the large-circulation magazines was not only a lucrative plum, but an endorsement of its creator's talents. During the early twentieth century, the

magazine cover offered wide exposure equivalent to that of television today. Readers clamored to see the latest pictures by such admired illustrators as Charles Dana Gibson, one of the highest-paid magazine illustrators in America—who in 1920 received $100,000 for 100 drawings from *Collier's* magazine alone—and a legendary presence in American media during the first three decades of the twentieth century. With the exposure provided by the magazine cover, it was one of the most cherished publishing venues for artists and illustrators.

Magazines made the artists' reputations, but the artists defined the visual personalities of their magazines. *Good Housekeeping*, for example, was referred to as Coles Phillips' magazine, because his cover illustrations of exquisitely stylized Gilded Age women encouraged brisk sales for many years. And although Norman Rockwell, like Phillips and many other leading freelance illustrators, also appeared on other magazine covers, he was so inextricably wed to the visual identity of the *Saturday Evening Post* that it became his personal stage. Because the truly great illustrators helped achieve high circulations, they were not treated as hired hands who slavishly rendered an editor's ideas (although some did), but as authors of imagery.

Most cover artists were not, however, *entirely* free to exercise their whims and preferences. Actually, they were more like court painters than expressive bohemians. While maintaining creative integrity, they pictorially advanced the goals of their magazines as determined by the editors. Some magazines allowed great leeway in this representation. The early *Fortune*, for example, had a dozen or so regular cover artists whose poster-like illustrations symbolized a wide variety of the issues covered in this exquisitely designed

business magazine. Likewise, *Vanity Fair*, the sophisticated cosmopolitan magazine, gave considerable license to its primary cover artists—Miguel Covarrubias, William Cotton, and Paolo Garretto—who created cover art on a wide range of social, cultural, and political themes. On the other hand, the *Golden Book*, the *Blue Book*, *Cosmopolitan*, the *Delineator*—and generally most fashion and household magazines—ran variations of the same cover. Indeed, the challenge of how to make these recurring themes graphically unique was a problem that was often solved by hiring the most original stylists. In the 1930s, the *haute couture* publications—*Harper's Bazaar* and *Vogue*, for example—employed the exceptional styles of such artists as Erté, A. M. Cassandre, and Eduardo Benito to give their covers artistic distinction.

For many Americans, the magazine cover was this nation's highest art—in fact, their only contact with any art. But what is called art is subjective. Distinctions between "fine" and "commercial" art add to the confusion. But for many Americans living between the late nineteenth and early twentieth centuries, exposure to—and interest in—fine art was so limited that the magazine became their introduction to artistic imagery. A plethora of profusely illustrated magazines came into the home and became part of daily life. By the turn of the century, advanced printing technology had made color magazine covers ubiquitous and had a quantifiable impact on the public's eye. It would therefore be logical to assert that magazine cover art guided the public's perception as to what art—or at the very least what popular art—should be.

Although art historians tend to avoid discussing this relationship, America's fine art

history intersects and is often intertwined with commercial art. America's great narrative painters, such as Thomas Eakins, William Merrit Chase, and Robert Henri, encouraged followers and students to work in the applied arts. During the nineteenth century, both Winslow Homer and Frederic Remington frequently created illustrations for *Harper's Weekly*. In fact, their early reputations were based on their work as illustrators. At the turn of the century, members of the legendary "Eight"—some of whom also comprised New York's "Ash Can School" of documentary, realist painters—became newspaper and magazine illustrators, both to earn a living and to hone their skills. Among them, George Bellows and John Sloan created many editorial illustrations and some covers for the *Masses* in a journalistic style that would later be translated into paintings and prints. Edward Hopper, who so brilliantly captured the desolation of urban life in his mature canvases, was in his younger years an editorial and advertising illustrator and did covers for such trade magazines as *Tavern Topics* and *Hotel Management*.

Most masters of American fine art only dabbled in the commercial arena, but the true masters of American illustration—James Montgomery Flagg, J. C. Lyendecker, F. C. Lyendecker, Harrison Fisher, et al—developed styles that somehow defined this nation's *zeitgeist*. While shunned by purist art historians who refused to acknowledge even the slightest thread connecting absolute creative expression and commercially inspired art, the great magazine covers—those that transcended their ephemeral natures and became documents of their times—represented a high-level artistic endeavor.

The key distinction between fine and commercial art is that the latter is commis-

sioned by a client. In addition, the image is often supervised by an intermediary, which in the case of a magazine cover is usually the art director. This title shows up in magazines at the turn of the century, first appearing in the *Burr McIntosh Monthly*, where its billing was subordinate to the art editor. The distinctions between these two jobs were once significant, though art editors are all but extinct today. During the early twentieth century, the art editor was responsible for commissioning art and illustration while the printer did the design and makeup of the publication. The amount of the art editor's interference in the actual rendering of a drawing or painting depended on his level of competence and expertise; aesthetics were usually less important than the literal details of a picture anyway. Most art editors would select an exact passage from a manuscript for the artist to illustrate and would edit the result as if it were text. The art director, on the other hand, was a hybrid, a cross between an artist and editor; he not only commissioned artwork, he contributed ideas, suggested the composition, and was sometimes even involved in the rendering itself. The art director soon usurped the role of the printer in the overall page design of the magazine. By the mid-twentieth century, most art directors determined what and how art would be used.

When it came to covers, the role of the art director was, as it is today, ultimately subordinate to that of the editor. While the art director made recommendations—and physically worked with the illustrator—the editor routinely selected the artist and cover theme. Between 1900 and the 1940s, many magazines didn't even relate covers to an inside story, but selected an image that expressed a general mood, specific season, or a provocative newsworthy idea. Routinely, fashion magazines showed women in the season's new frocks;

romance magazines showed pictures of starry-eyed men and women together; household magazines showed better homes and gardens; travel magazines showed distant lands; humor magazines showed silly gags; and political magazines showed a variety of flags and symbols. The leading general magazines offered a regular diet of seasonal vignettes, except when national or world events demanded a more targeted image.

At the turn of the century and for a couple of decades following, magazines had not yet ossified into rigid conventions that would stymie even the best art directors and design-ers. By the 1960s, a typical mass-market magazine cover became an impenetrable wall of headlines through which the diminished image struggled to peek through. Although a few popular periodicals still adhered to the quaint late-nineteenth-century convention of using the same cover art (often an illuminated frame, border, or decorative masthead) each issue, most of the leading national magazines had gone modern and commissioned different illus-trations for each issue. The more adventuresome magazines even altered their logos or mastheads on a regular basis.

Influenced by the late-nineteenth-century German magazine, *Jugend*, which pio-neered the mutable logo, these often hand-drawn magazine titles gave the cover a poster-like sensibility. The decision to alter the logo was not based on whether the editor or art director felt that the cover design benefited from such ad-hocism. *Harper's, Leslie's*, and *Collier's*, among the established journals, adhered to a standard logo (which was re-designed occasionally, but only when overall formats were changed). Conversely, high-circulation magazines, including *Life, Judge, Vanity Fair, Harper's Bazaar*, and *Vogue*—as

well as the lower-circulation the *Masses, Liberator,* and *Playboy*—used lettering and typography, often rendered by the cover artist, to complement the artwork.

In contrast to the current prevailing wisdom that a logo or masthead must be consistently recognizable lest the reader become dazed and confused, early-twentieth-century American magazines had a better lock on their audience. Readers stayed loyal to their magazines for longer periods because these periodicals became integral parts of daily life. Graphics had become a very important—and sometimes a deciding—factor in how a consumer initially responded to a magazine. Circulation decidedly increased from the late nineteenth century onward after the typical all-type covers were replaced by graphic ones. Nevertheless, critics like Arthur Reed Kimbal in *Journal of Science,* 1899, voiced a not uncommon opinion at the time that "modern publishers seem to think that the eye measures the depth of the popular mind," and that in the new profusely illustrated publications, "the writers are only space fillers." But Frank Luther Mott reported that "all critical protests were in vain: the people liked copious illustration." And by extension, they loved lavishly illustrated covers that opened their eyes to new perceptions.

Photography was introduced to magazines in the late 1890s and revolutionized illustration before it became an illustration medium in its own right. Photography made possible the reproduction of paintings and tone drawings from originals without laboriously copying them onto a litho stone or engraving. The Ives Process—named after its inventor Frederick E. Ives, and later commonly known as the halftone process—allowed for the photographic reproduction of, first, black-and-white tone, and, later, full-color paintings. Prior

to Ives' invention, a few color magazine covers were printed as chromolithographs, a costly, time-consuming process. The earliest photographically reproduced color covers from around the turn of the century excited and enticed the magazine reader every bit as much as the first color television programs that appeared on NBC in the 1950s. By 1910, most magazines were running illustrated color covers (and color advertisements on the back cover).

Photography was occasionally used on magazine covers prior to the premiere of Henry Luce's *Life* magazine in 1936, but it would take decades to surpass the public popularity of illustration. Editors and art directors felt that painting, drawing, and even collage was a more controllable medium from the standpoint of editorial manipulation. Although photo-retouching was available and regularly employed to remove unwanted blemishes, it was nevertheless more difficult and costly to stage or orchestrate a photograph than paint a picture. Illustrators could more easily achieve fantastic, romantic, monumental, heroic, and other hyper-realistic or stylized effects. In the 1890s, poster art had become extremely popular—to the extent of being a fad—and the magazine cover was considered a mini-poster. The poster's influence on magazines, or what Frank Luther Mott refers to as the cult of the poster, continued into the 1930s.

By the 1930s, magazine superiority was challenged by other mass media, including movies and radio. Newspaper circulation was at an all-time high. The Great Depression also effectively limited the amount of paid advertising earmarked for magazines, which further forced their publishers to rely on hard-sell methods at the newsstand. So screaming coverlines were printed on, over, and above the cover art. Logos were standardized, and

illustrations started to rigidly conform to the styles and fashions that circulation and marketing experts believed would appeal to the consuming public. Editorial illustration soon began to mimic advertising and billboard art. From the late 1930s through the 1950s, the general magazines—including *Liberty*, the *American*, and *Pictorial Review*, which mimicked the *Saturday Evening Post* and *Collier's*—fed their readers a fairly regular diet of realistic illustration. These covers were devoid of the ornamentalism that signified 1920s and 1930s *art moderne* style, but were idealizations of real-life scenes. In 1936 *Vanity Fair* was folded into *Vogue*, and with its demise, the often acerbic cartoons and caricatures that had defined the Jazz Age disappeared. By the 1940s, *Vogue* relied more on photography, and *Harper's Bazaar* and the other leading fashion magazines followed suit. By the 1950s, the *Saturday Evening Post, Collier's*, and of course the *New Yorker* were the only magazines to religiously continue the illustrated cover tradition. Illustration was also regularly used on pulp magazines or "confessions" covers and sporadically by other publications, but these had become rather tawdry. By the 1960s, even the behemoth magazines had turned to photography as a last-ditch effort.to be contemporaneous and compete with television. In 1961, the *Saturday Evening Post*, the voice of middle America, redesigned its entire format to be more up-to-date. Although the first new cover was a portrait by Norman Rockwell of designer Herb Lubalin at a drawing board admiring the *Post*'s new logo (in a parody of Rockwell's own famous self-portrait), the new format demanded that Rockwell update his illustrative approach by including faddish background patterns and colors. Finding this untenable, he left the "new" *Post* for *Look*, where he made interior illustrations instead of covers.

By the 1960s, photography had almost totally surpassed illustration in cover art. Even before that, magazine covers were considered too valuable to be given over entirely to art. Museums may be cultural wellsprings, but department stores attract many more customers; hence, marketing experts dictated that "gallery quality" magazine covers be replaced with editorial window displays. By the 1950s, illustration was nudged out. Within less than a decade the golden age had become a memory.

Cover Story begins in 1900 because that date marked the birth of a powerful new medium with unlimited potential for artists. It ends in 1950, not because the magazine covers that came after were inferior, but because photography, typography, and mixed media superseded illustration. Paul Rand's 1940s collages for the small cultural magazine, *Direction* mark the beginning of the shift away from traditional illustration. Prior to 1950, magazine covers were by no means free of marketing interference, but the level was quite different. Although hundreds of innovative covers have been produced since 1950, the fundamental processes (and rationales) have changed. It could be argued that there is more than one golden age of magazine covers. During the late 1960s, for example, conceptual magazine cover design was at its peak, notably with *Esquire* and *New York* magazines; and in the 1980s, an increase in experimental or avant-garde typographic approaches emerged. But the covers shown in *Cover Story* reflect a period when American magazine publishing was finding its audience and when American illustration was at its height. *Cover Story* is therefore a story of how commercial art set the standard for American art, and how magazines, whether as galleries or shop windows, presented this art to the public.

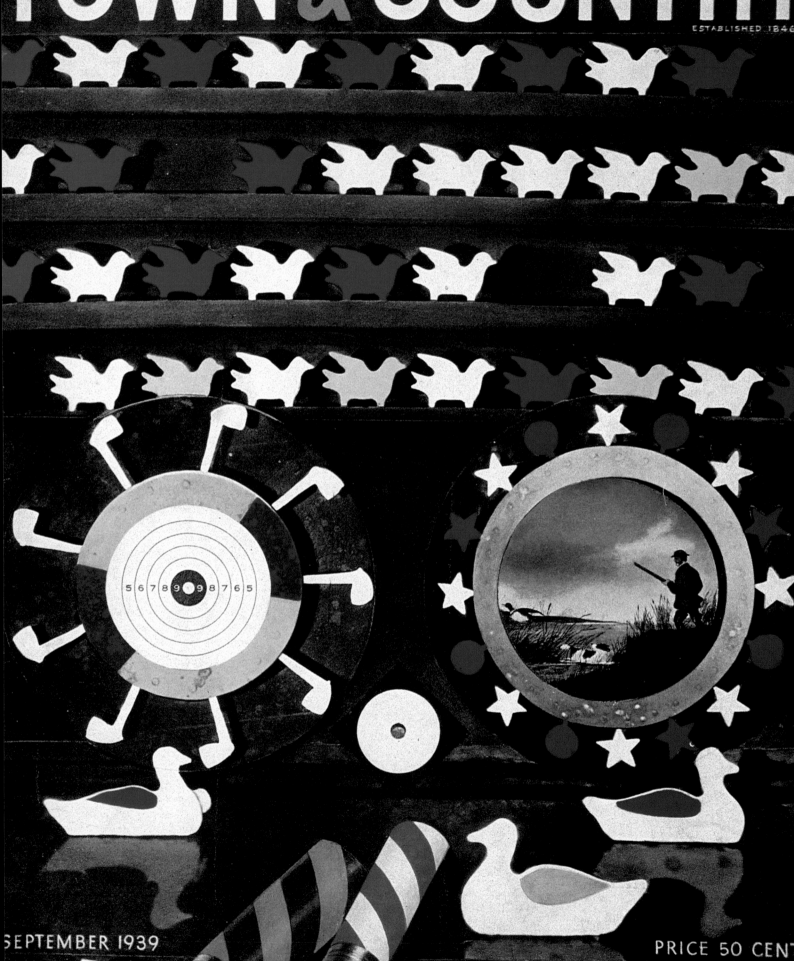

It has the buzz of the 1980s, but the concept of lifestyle dates back to the turn of the century, when it was one of the principal themes addressed and exploited by magazine publishers. Under this rubric, magazines devoted to enhancing and preserving life in the home, community, and specifically on

COVERING LIFESTYLE

society focused women's roles

as homemakers and social as women's magazines began tury and promoted what "the interests of higher life various levels of social class magazines, generally the ed an editorial mix of ser- appropriate fiction to appeal managers. A genre known in the late nineteenth cen- *Good Housekeeping* called in the household." Although were addressed in different women's magazines offer- vice features, critiques, and to a female audience. The

covers ran the gamut of images, from idealized and mythic women (not suffragettes or early feminists by any stretch) to prosaic vignettes and still-lifes, and stylized symbolic representations of the dream home. Readers were encouraged by the cover art to see themselves and their environments as components of a blemish-free America. For decades, the art for *Woman's Home Companion, House Beautiful,* and *House & Garden,* among the most popular, established the expectation that daily life was unthreatening, if not also glorious; the cover art rarely referred to the often quotidian content of the magazine, but rather the heroic aspects of life in the home.

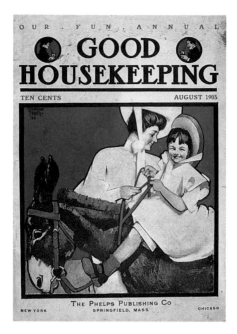

GOOD HOUSEKEEPING

AUGUST 1905

ARTIST: HENRY McCARTER

The proper American woman, as this
typical cover suggests, was a good homemaker
and attentive mother, and dressed well, too.

GOOD HOUSEKEEPING

AUGUST 1915

ARTIST: COLES PHILLIPS

Phillips' idyllic woman defined a mag-
azine that was published "in the interest
of higher life in the household."

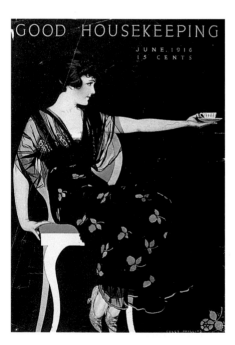

GOOD HOUSEKEEPING

JUNE 1916

ARTIST: COLES PHILLIPS

Phillips was a virtuoso whose
paintings accentuated the female form and
proffered an American modern style.

OPPOSITE:
GOOD HOUSEKEEPING

FEBRUARY 1917

ARTIST: COLES PHILLIPS

This simple composition of a fashionable
and proper woman is a virtual recruitment
poster for genteel society.

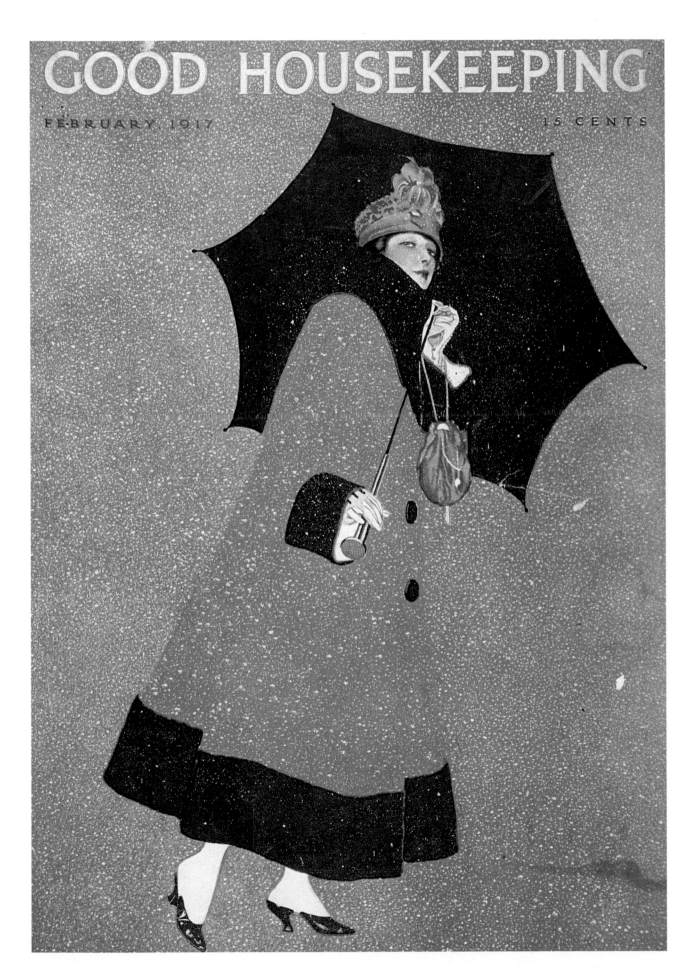

GOOD HOUSEKEEPING

FEBRUARY 1917

15 CENTS

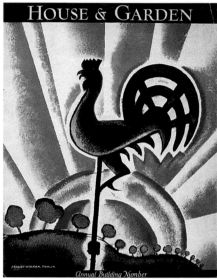

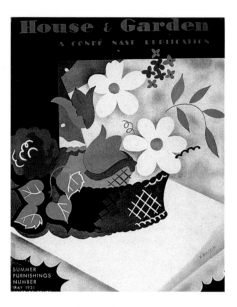

HOUSE & GARDEN
FEBRUARY 1921
ARTIST: H. GEORGE BRANDT
Early covers were obsessively ornamental
in the manner of art nouveau
and anticipated the excesses of art deco.

HOUSE & GARDEN
JANUARY 1928
ARTIST: BRADLEY WALKER TOMLIN
Stylized wind vanes presented the idea of
the gentleman farmer, the weekend exurbanite
that the magazine sought to attract.

HOUSE & GARDEN
MAY 1931
ARTIST: R.B. KOCH
Covers ran the conceptual gamut from
still lifes to gardenscapes. This stylized
setting was typical of its period.

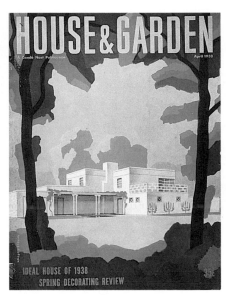

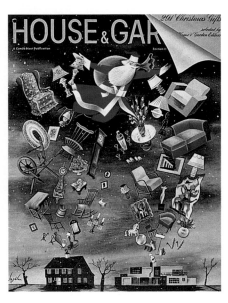

HOUSE & GARDEN

JANUARY 1938

ARTIST: JOSEPH BINDER

Cover art depicted the genteel lifestyle

while its contents featured architecture,

decoration, and gardening.

HOUSE & GARDEN

APRIL 1938

ARTIST: WITOLD GORDON

Before Corbusier inspired houses became

even moderately popular, *House & Garden*

ran this modernistic cover.

HOUSE & GARDEN

DECEMBER 1938

ARTIST: CONSTANTIN ALADJÁLOV

Even in 1901 when it was founded,

this magazine was intended for those

with above-average incomes.

The HOUSEHOLD MAGAZINE

OCTOBER 1931

FIVE CENTS

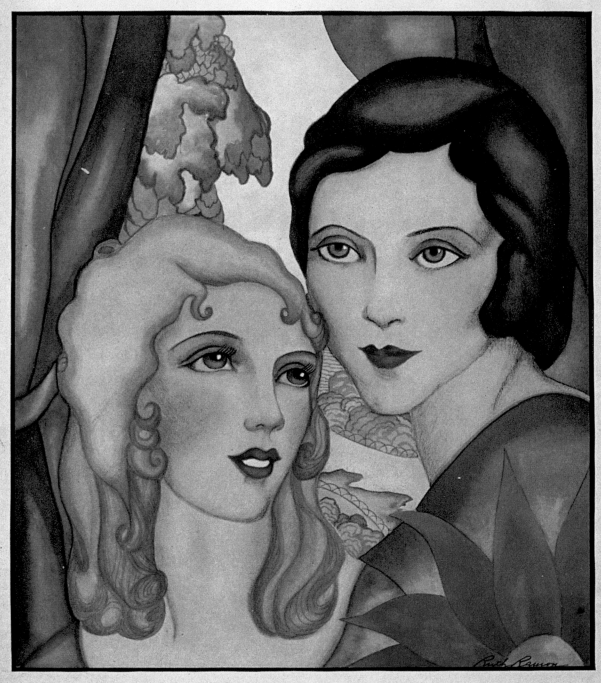

THE STAIRCASE, Hugh Walpole's brilliant story
of misunderstanding, love, and justice in an ancient house

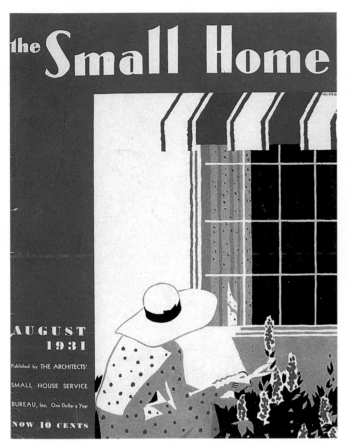

THE SMALL HOME

AUGUST 1931

ARTIST: MCNEAR

As the cover suggests, this was a
magazine for those of modest incomes who
owned and maintained their own homes.

THE SMALL HOME

NOVEMBER 1931

ARTIST: MCNEAR

Covers were seasonal and either focused
on the housewife, the home, or the garden
during states of natural transition.

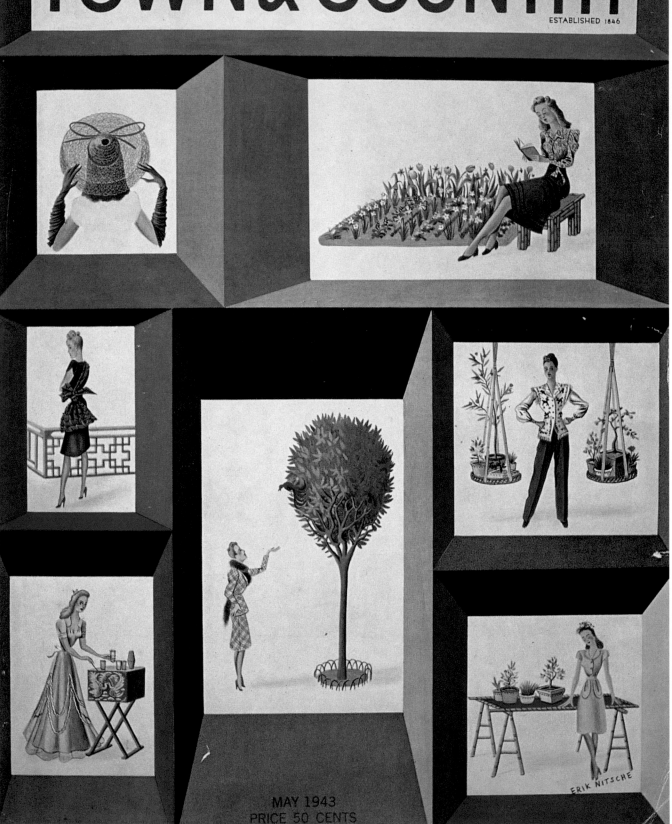

TOWN & COUNTRY

ESTABLISHED 1846

MAY 1943
PRICE 50 CENTS

ERIK NITSCHE

26

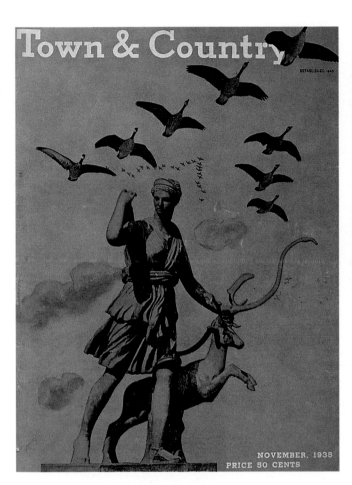

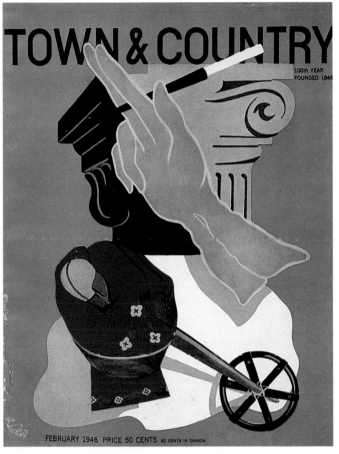

TOWN & COUNTRY

NOVEMBER 1935

ARTIST: LESLIE GILL

Covers often symbolized the leisure activities
of the affluent; this one was published in time
for duck hunting season.

TOWN & COUNTRY

FEBRUARY 1946

ARTIST: HENRY BILLINGS

In the manner of the European *moderne*
poster, this cover symbolically refers to the
winter frolics of the leisure class.

Woman's Home **Companion**

July 1931 Ten Cents

SUMMER

© The Crowell Publishing Company

OPPOSITE:

WOMAN'S HOME COMPANION

JULY 1931

ARTIST UNKNOWN

The Ladies Home Companion, founded in
1885, changed its name in 1897 and became
focused on the modern woman's lifestyle.

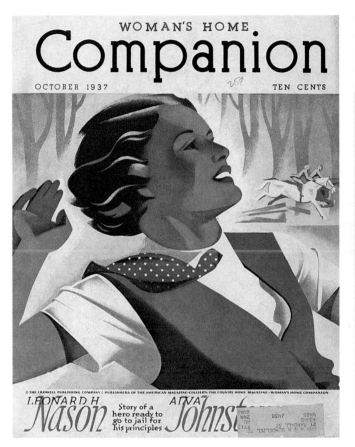

WOMAN'S HOME COMPANION

OCTOBER 1937

ARTIST: JOSEPH BINDER

This cover, by the creator of the
Doublemint Twins in the 1940s, depicts
a genteel woman's leisure activity.

WOMAN'S HOME COMPANION

MAY 1938

ARTIST: WILL WELSH

Glamorous "cover girls" began appearing
on magazines in the nineteenth century and
continued to be effective selling tools.

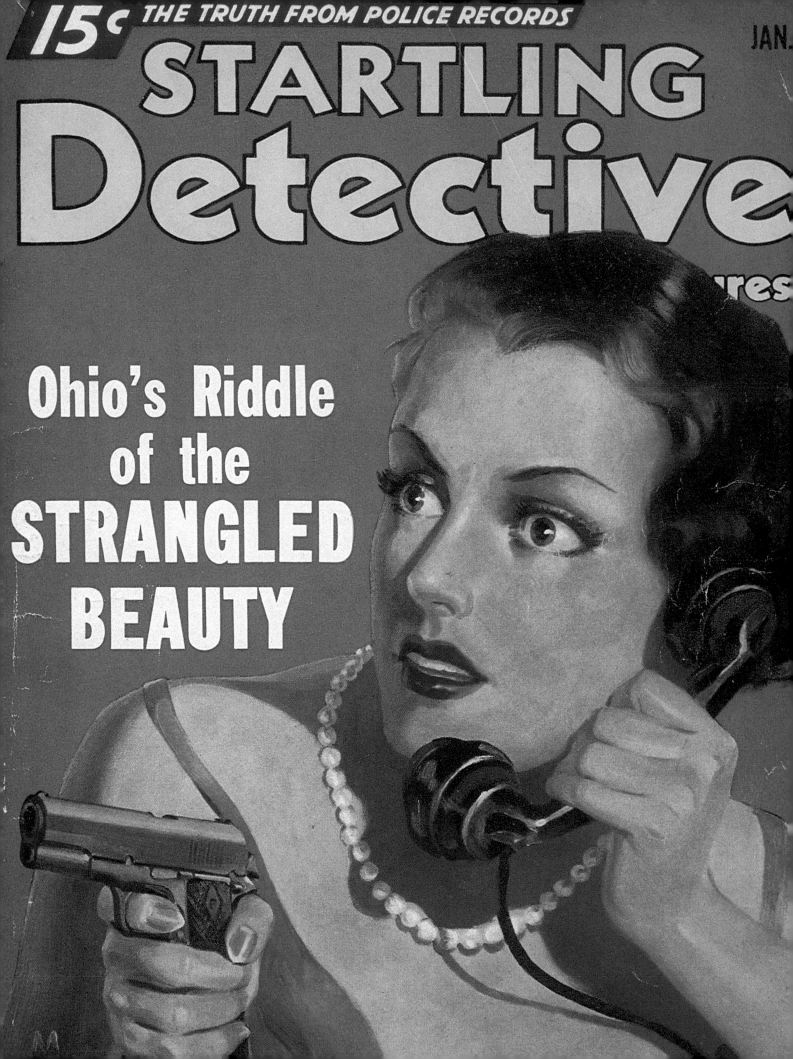

Before tawdry crime and romance magazines hit the American newsstands, the genre known as pulps, which began in the nineteenth century, included action and adventure periodicals printed on cheap newsprint. In 1919, publisher Bernarr Macfadden premiered

COVERING THE PULPS

a new kind of pulp—*True Story*—the cover of which featured a starry-eyed couple and the now-famous saying "Truth is stranger than fiction." The cover also offered $1,000 for "Your Life Romance." This was the beginning of an exceedingly popular genre of true confession magazines that caught on like wildfire (by 1926, *True Story* had an astounding 2,000,000 newsstand circulation). Macfadden simply acknowledged what had been known in other publishing fields: that the narrative of a real-life experience—seduction, murder, or abuse—had a riveting effect on the public. Macfadden geared this material toward the many thousands who didn't read magazines because they were ignored by publishers for not having the money or education to be targeted by national advertisers. It was for this audience that the paradigmatic pulp cover was designed with stark (lustful) paintings, bold logos, and numerous gothic and slab serif coverlines. In the movie poster tradition, the hyper-realistic paintings underscored a key portion of the mystery, action, or romance; just realistic enough to be provocative, and mysterious enough to pander to the audience's voyeurism.

OPPOSITE: **STARTLING DETECTIVE** JANUARY 1936 ARTIST: "M"　ABOVE: **CRIME DETECTIVE** FEBRUARY 1938 ARTIST UNKNOWN

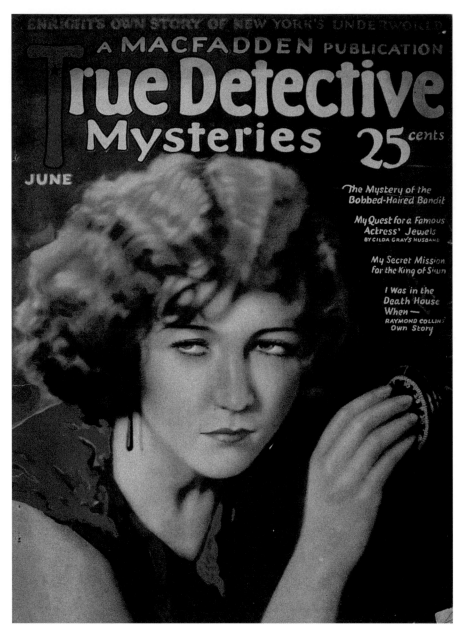

OPPOSITE:
TRUE DETECTIVE
JUNE 1950
ARTIST: RICHARD CARDIFF
Note the distinctive changes in both type and
characterization from the 1930s to the 1950s.
Only the sense of mystery remains the same.

TRUE DETECTIVE MYSTERIES
JUNE 1924
ARTIST UNKNOWN
(taken from a photo)
For this issue of one of Bernarr
Macfadden's top-selling reality-based pulps,
a fearless woman perpetrates a crime.

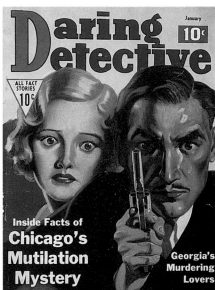

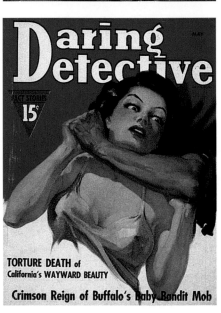

DARING DETECTIVE
JANUARY 1936
ARTIST UNKNOWN
The illustrator of these covers had to be skilled
at realistic and melodramatic rendering.

DARING DETECTIVE
MAY 1938
ARTIST UNKNOWN
In a typical pose, a sensual woman
is pitted in a gripping life-and-death
struggle with a menacing male.

TRUE DETECTIVE

June
25¢

BEHIND the SCENES
with an
ACE DETECTIVE

True Story

TRUTH [STRONGER] THAN FICTION

MAGAZINE
JANUARY

15¢

A MACFADDEN PUBLICATION

I GREW UP
IN SING SING
by ALABAMA PITTS

Vichelche

BIG NEW $25,000.00 CASH PRIZE CONTEST

OPPOSITE:

TRUE STORY

JANUARY 1936

ARTIST: VICTOR TCHETCHET

True Story was the first of the
confession magazines. Here the ideal
couple represent Americans in love.

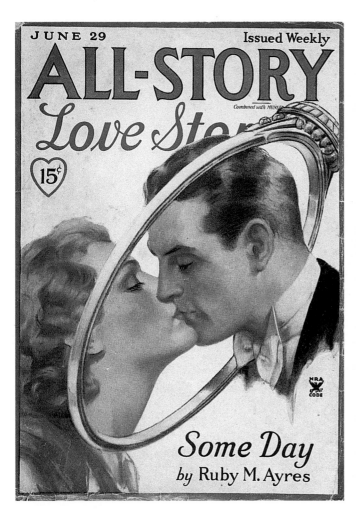

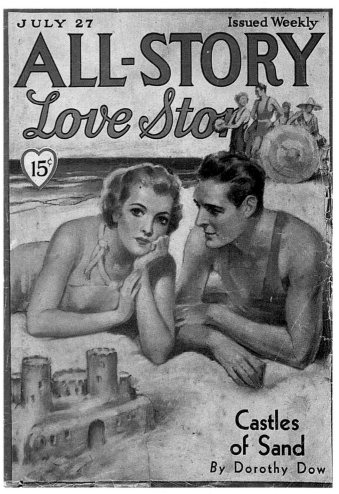

ALL-STORY LOVE STORIES

JUNE 29, 1935

ARTIST UNKNOWN

This weekly's covers are the visual
equivalents of the modern soap opera drama.

ALL-STORY LOVE STORIES

JULY 27, 1935

ARTIST UNKNOWN

Little is left to the imagination in this rather
bland rendering of love's trials and travails.

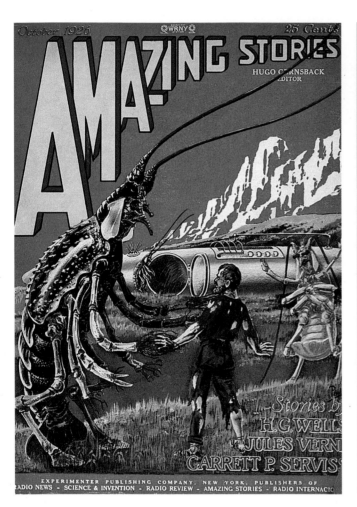

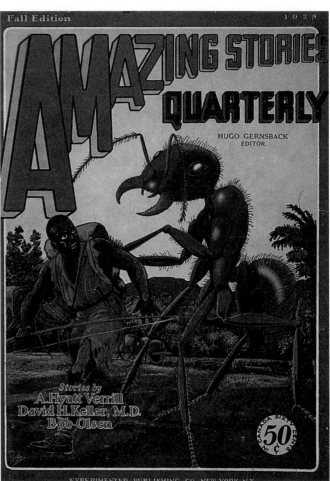

AMAZING STORIES

OCTOBER 1926

ARTIST UNKNOWN

The table of contents reads, "The fearful lobster-like creatures are shown investigating the, to them, strange human creature."

AMAZING STORIES QUARTERLY

FALL 1928

ARTIST: R.E. LAWLOR

Next to frightened, scantily clad women, grotesque menacing insects were the best-selling cover subjects in this genre.

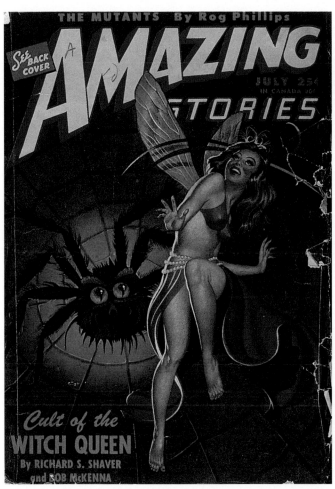

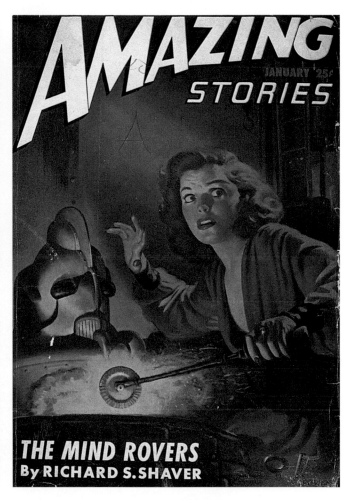

<div align="center">

AMAZING STORIES

JULY 1946

ARTIST: MALCOM SMITH

These digest-sized magazines packed a visual

wallop on the newsstand. Here a sensuous

Tinker Bell finds herself in a difficult situation.

</div>

<div align="center">

AMAZING STORIES

JANUARY 1947

ARTIST: H.W. MCCAULEY

Part comic book, part paperback. The secret to

graphic success is human emotions; in this example,

fear plus lust equals reader interest.

</div>

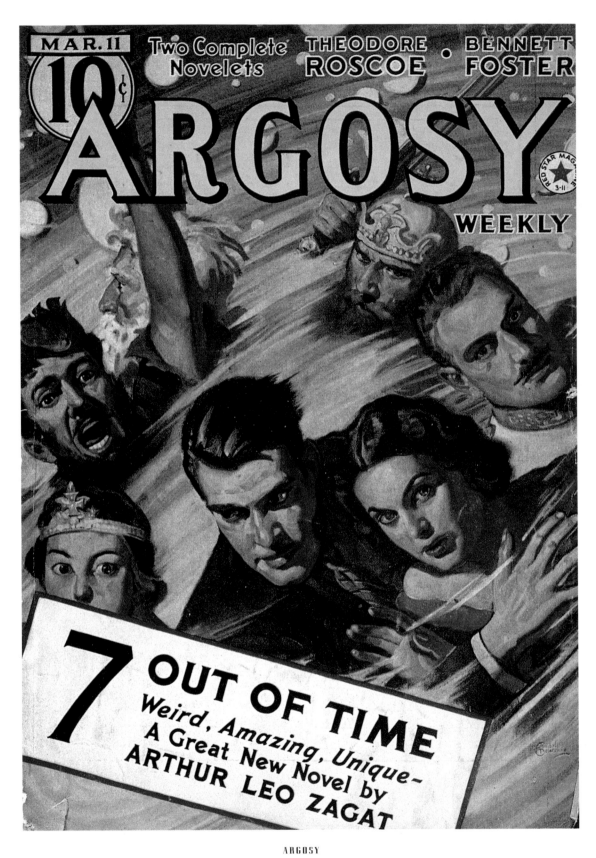

ARGOSY

MARCH 11, 1939

ARTIST: RUDOLPH BELARSKI

Originally published in 1882 as a
magazine for children, it was transformed
into the first modern pulp in the 1890s.

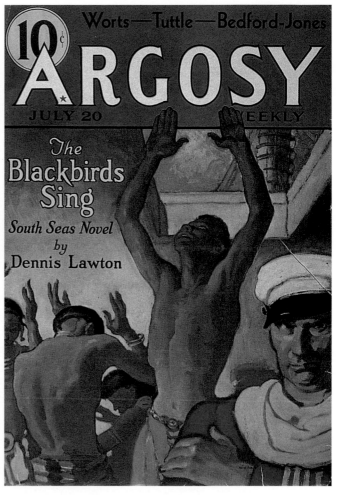

ARGOSY

APRIL 27, 1927

ARTIST: C. COLVERT

This men's weekly offered a range of
fantasy, war, and crime dramas, with covers
illustrated in the American realist mode.

ARGOSY

JULY 20, 1927

ARTIST UNKNOWN

Credit was rarely given for *Argosy* covers,
so it was up to the illustrator to position his
signature where it couldn't be cropped out.

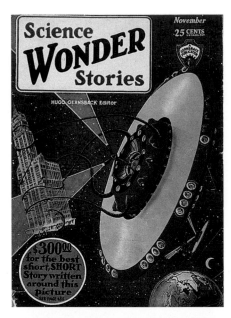

ASTONISHING STORIES
APRIL 1941
ARTIST: "RCS"

As the logo shoots across the top of
this magazine, a heroic rendering of
space cowboys beckons the reader.

WONDER SCIENCE STORIES
NOVEMBER 1929
ARTIST UNKNOWN

This surrealistic picture illustrates the
winning entry in a "short, short story contest."
The editor states he didn't have the
"remotest idea as to what it is all about."

SUPER SCIENCE STORIES
SEPTEMBER 1940
ARTIST UNKNOWN

With its comic book logo, this cover suggests
naive visions of intergalactic societies where men
and women are always scantily dressed.

FIVE NOVELS

MARCH 1934

ARTIST: FREDRIC C. MADAN

Before inexpensive paperbacks
cornered the middlebrow literary market,
magazines such as this did the job.

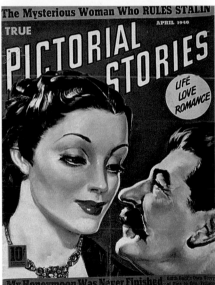

FAMOUS FANTASTIC MYSTERIES

DECEMBER 1945

ARTIST: LAWRENCE

Even the mystery magazines exploited
the romantic tensions between man and
woman to engage the reader.

TRUE PICTORIAL STORIES

APRIL 1940

ARTIST: CHARLES DEFEO

Rendered with all the honesty of Socialist realism,
this portrait of Stalin and his lover suggests the
warmer side of the Russian dictator.

In terms of magazine publishing, America has three cultures: highbrow, middlebrow, and lowbrow. The pulps easily fit into the low category, while art, literary, and poetry magazines fit into the high. The middle ground, however, has broader boundaries. On one end are such magazines

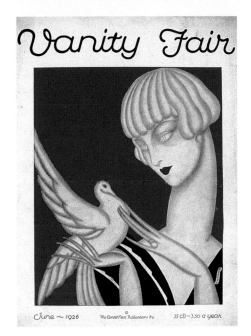

COVERING CULTURE

and *Motion Pic-* purported to inform the ing popular art. On the *Dance Lovers*, with its pulp- line between dance as art the other end are *Stage*, which reported on the these entertainments. Their define the mass culture of

as *Motion Picture ture Classic*, which masses about this burgeon- same end of the spectrum, like cover design, toes a fine and as exhibitionism. On *Theater*, and *The Dance*, more popular modes of smartly illustrated covers their times. Straddling the

fence between middle- and highbrow, *Vanity Fair* was the most influential magazine of the late 1920s and early 1930s. Its covers, illustrated by Miguel Covarrubias, William Cotton, and Paolo Garretto, were the highest forms of satiric illustration and graphic commentary. As its title suggests, it was a spotlight for the principal players in the arts, society, and politics. While its caricature covers distorted famous images ever so slightly, they also presented certain truths, such as Covarrubias' scabrously comical depiction of the Italian dictator Benito Mussolini. Cultural magazines allowed greater artistic license than most other genres and introduced the avant-gardisms that were adopted elsewhere.

OPPOSITE: **VANITY FAIR** FEBRUARY 1935 ARTIST: PAOLO GARRETTO ABOVE: **VANITY FAIR** JUNE 1926 ARTIST: DARCY

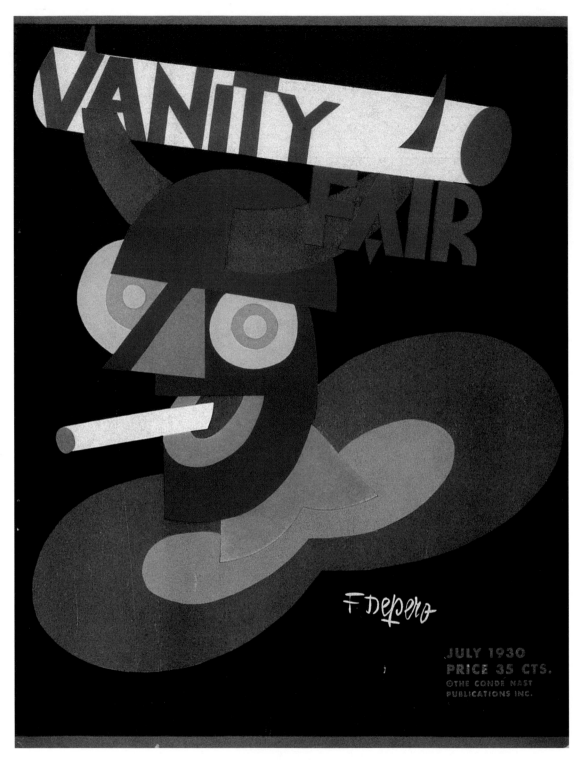

VANITY FAIR

JULY 1930

ARTIST: FORTUNATO DEPERO

This cover by an Italian futurist
advertising artist makes an ironic comment
on the fashion for cigarette smoking.

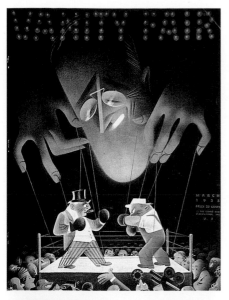

VANITY FAIR
MARCH 1935
ARTIST: PAOLO GARRETTO
In "The American Puppet Show" Franklin
D. Roosevelt manipulates the animosities
between the worker and the wealthy.

VANITY FAIR
AUGUST 1926
ARTIST: ANNE H. SEFTON
Before M.F. Agah become art director the magazine's
covers were pretty, though benign, stylistic vignettes.

VANITY FAIR
OCTOBER 1932
ARTIST: MIGUEL COVARRUBIAS
This caricature of a stern Benito
Mussolini shows a Lilliputian King Victor
Emmanuel trying to get some attention.

VANITY FAIR
NOVEMBER 1930
ARTIST: CONSTANTIN ALADJÁLOV
The gridiron was also ripe for comic
commentary as portrayed in this cartoon
vision of the rough and tumble.

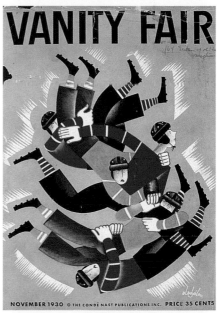

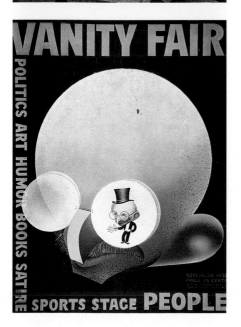

VANITY FAIR
NOVEMBER 1931
ARTIST: PAOLO GARRETTO
This airbrushed, *art moderne* caricature of Gandhi
comically portrays him as martyr and statesmen.

VANITY FAIR
MARCH 1930
ARTIST: CONSTANTIN ALADJÁLOV
The perceived absurdity of modern art was
a frequent subject for satire and parody.

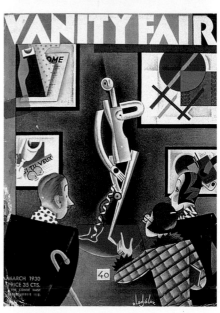

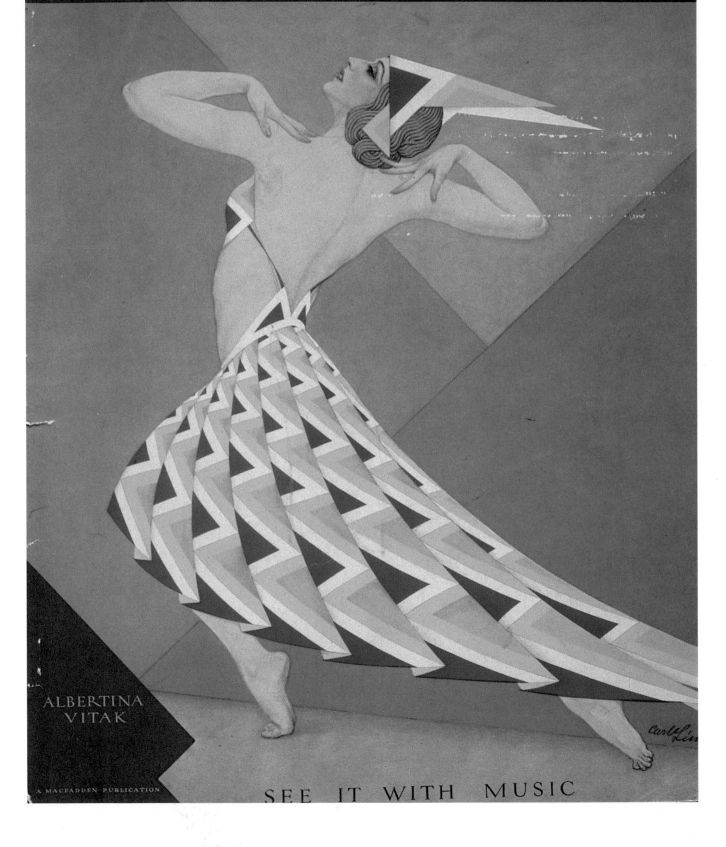

THE DANCE

35 CENTS MAGAZINE JUNE

ALBERTINA
VITAK

A MACFADDEN PUBLICATION SEE IT WITH MUSIC

OPPOSITE:

THE DANCE

JUNE 1929

ARTIST: CARLE LINK

This is an artist's streamline rendering
of dancer Albertina Vitak wearing one of
her modernistic dance costumes.

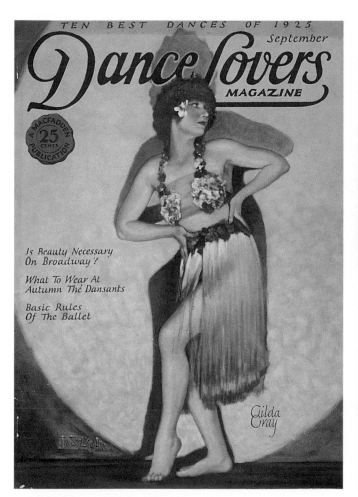

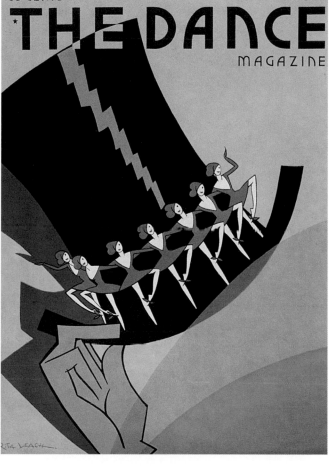

DANCE LOVERS

SEPTEMBER 1925

ARTIST: LEO SIELKE, JR.

Less culturally elevated is the realistic portrait
of Gilda Gray in a hula skirt. *Dance Lovers* was
a serious magazine in pulp disguise.

THE DANCE

JULY 1929

ARTIST: RITA LEACH

A more comical rendering of the
typical musical chorus line indicates that
this magazine covers the popular arts.

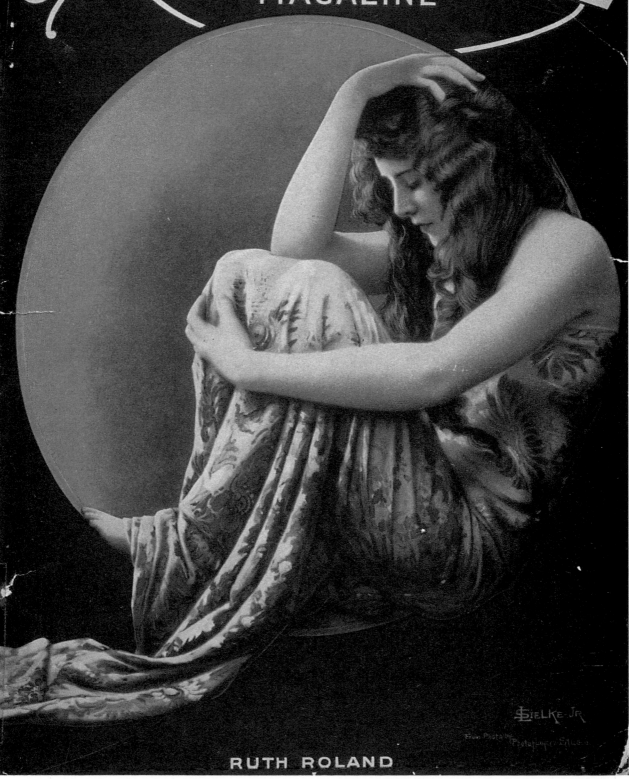

JUNE
Motion Picture
MAGAZINE
15 Cts.

RUTH ROLAND

OPPOSITE:

MOTION PICTURE MAGAZINE

JUNE 1925

ARTIST: LEO SIELKE, JR.

Actress Ruth Roland's intense pose became

typical of how film stars were portrayed *in situ*.

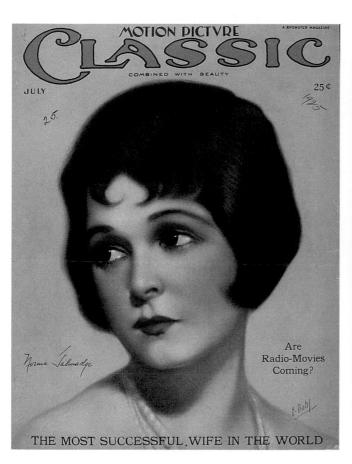

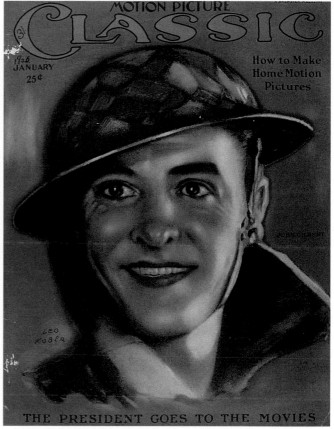

MOTION PICTURE CLASSIC

JULY 1925

ARTIST: E. DAHL

This classic portrait, rendered directly from a

photograph—in this case of Norma Talmadge—

was printed in deep saturated colors.

MOTION PICTURE CLASSIC

JANUARY 1926

ARTIST: LEO KOBER

John Gilbert's portrait shows him as his

character in a World War I drama. These covers

were meant to be torn off and hung on the wall.

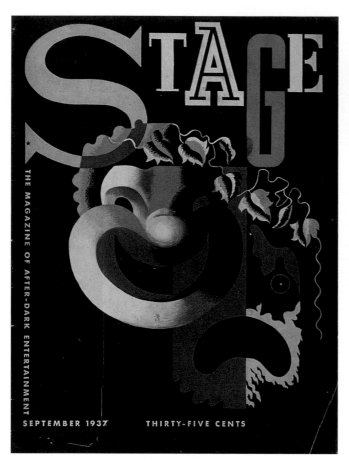

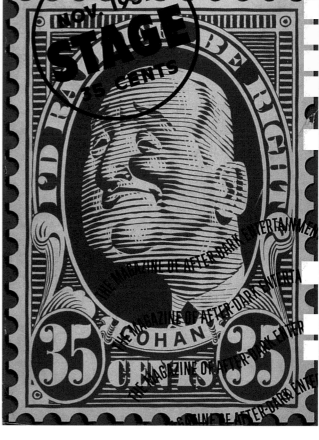

STAGE

SEPTEMBER 1937

ARTIST: FORTUNATO AMATO

Like *Vanity Fair*, this magazine
regularly changed covers and logos when
conceptual issues demanded it.

STAGE

NOVEMBER 1937

ARTIST: STUART S. GRAVES

A delightful caricature of George M.
Cohan, the Broadway impresario, is designed
to fit into a comic commemorative stamp.

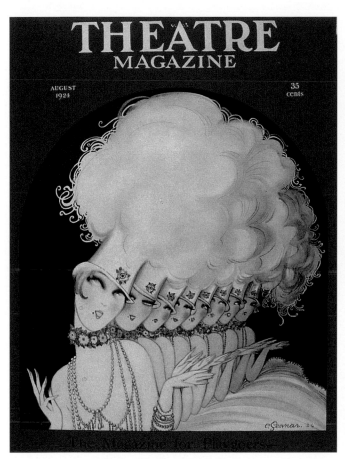

THEATRE MAGAZINE

AUGUST 1924

ARTIST: C. GESMAR

The costumes of this *moderne* chorus
line provide the perfect visual focal
point. The feathers form clouds.

THEATRE MAGAZINE

JULY 1929

ARTIST: A. DURENCENO

The glitz and glamour of the stage
provided the artistic inspiration for these
covers. Here is Nazimova as Salome.

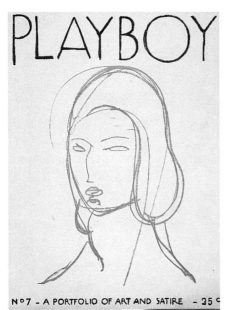

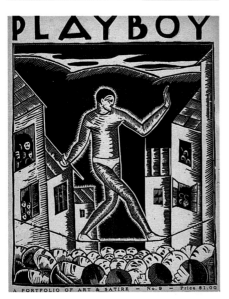

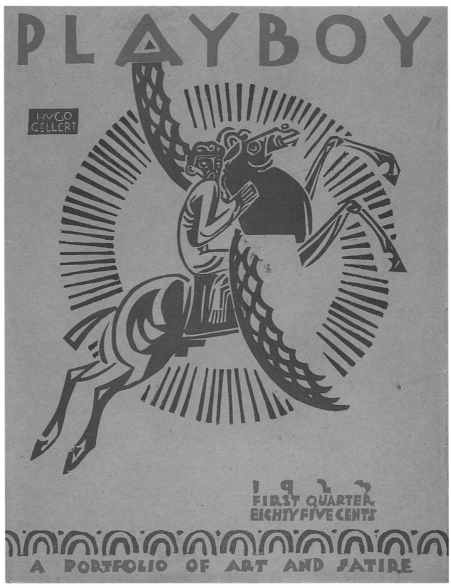

PLAYBOY

FIRST QUARTER 1923

ARTIST: HUGO GELLERT

The logos were drawn, sometimes
haphazardly, without regard for the
rules of typography or lettering.

PLAYBOY

JULY 1924

ARTIST: HONKA KARAZ

Cover artists changed from issue to issue,
and so did the illustration styles—from simple
sketches to expressionistic woodcuts.

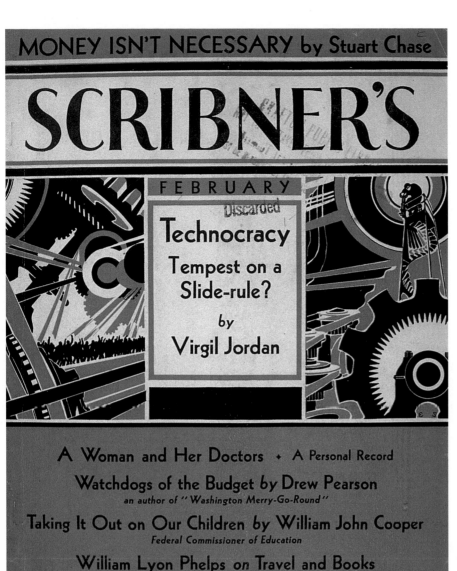

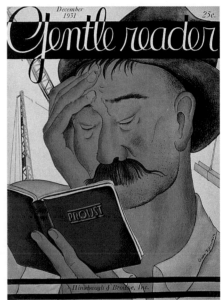

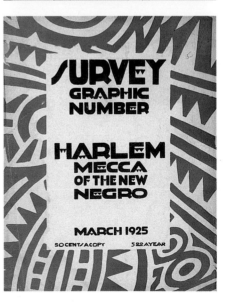

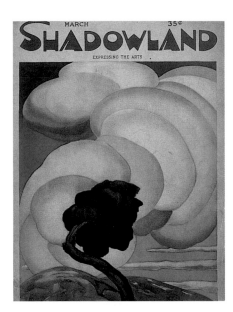 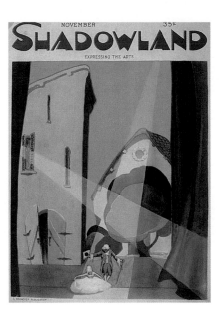 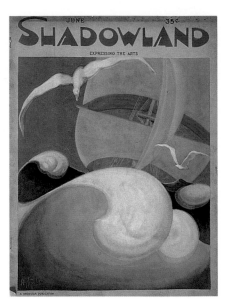

SHADOWLAND

MARCH 1922

ARTIST: A.M. HOPFMULLER

This magazine of the theater arts was
one of the most consistently beautiful
and uniquely stylish of its era.

SHADOWLAND

NOVEMBER 1922

ARTIST: A.M. HOPFMULLER

Its covers were designed and illustrated
by its art director, who was influenced both
by art nouveau and cubist painting...

SHADOWLAND

JUNE 1923

ARTIST: A.M. HOPFMULLER

His own cover paintings are taken directly
and indirectly from theater and dance scenery
and rendered in an uncommon pastel palette.

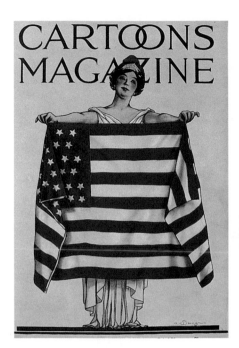

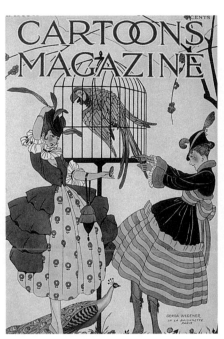

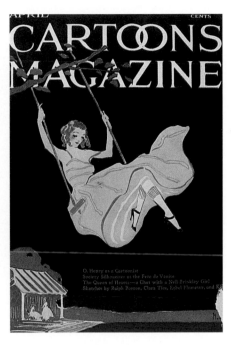

CARTOONS MAGAZINE
JUNE 1920
ARTIST: LANGAIN
This magazine was a digest of
the best international political and
social cartoons of the era...

CARTOONS MAGAZINE
MARCH 1920
ARTIST: GERDA WEGENER
...Covers were either commissioned
for the magazine or reprinted from other
journals around the world...

CARTOONS MAGAZINE
APRIL 1920
ARTIST: PLUNKET
...During World War I, covers were politi-
cally acerbic; afterward, they became more
prosaic, in contrast to the work inside.

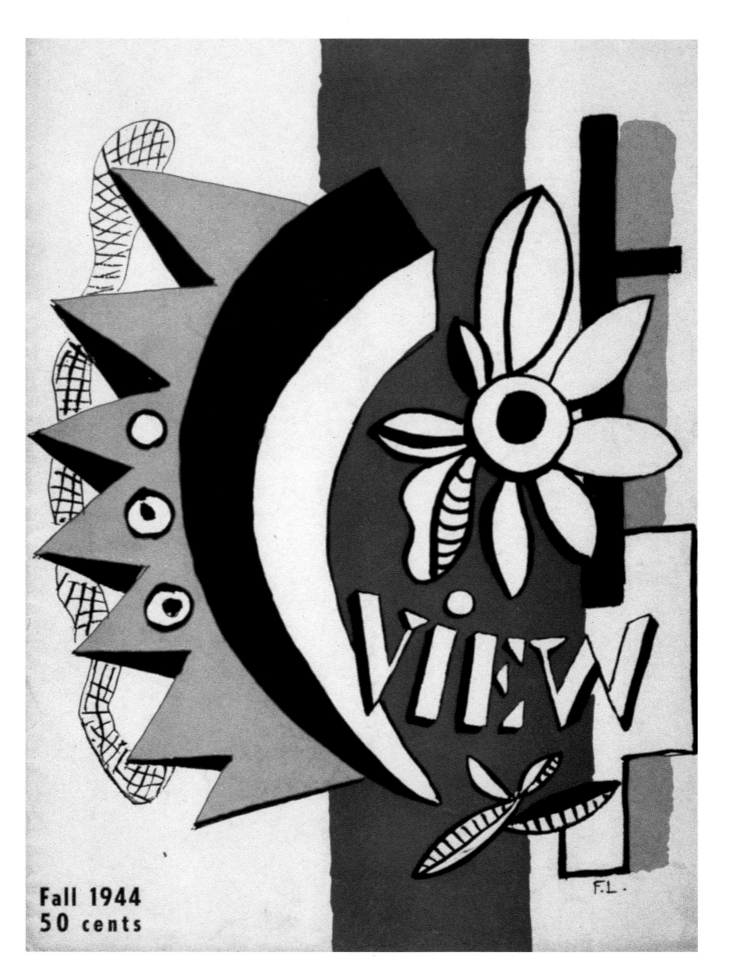

Fall 1944
50 cents

F.L.

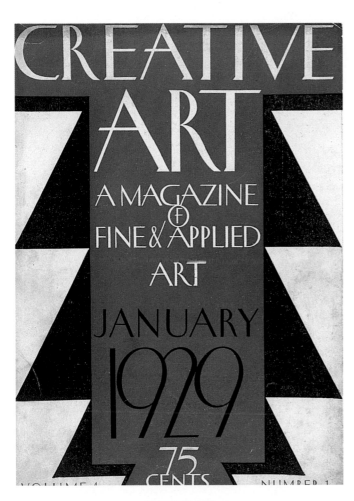

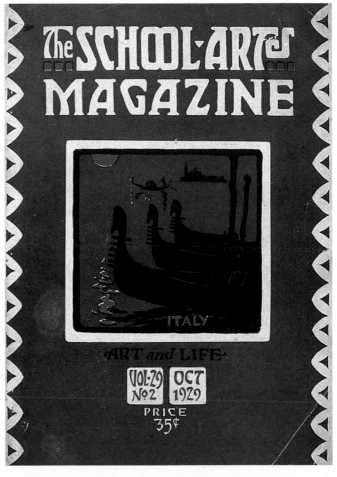

CREATIVE ART

JANUARY 1929

ARTIST UNKNOWN

This is an attempt to introduce art and archi-
tecture to the attention of the masses; curiously,
the covers are almost always the same.

THE SCHOOL ARTS MAGAZINE

OCTOBER 1929

ARTIST UNKNOWN

The colorful covers of this magazine almost
always adhered to the same decorative format
with an anonymous tableau in the middle.

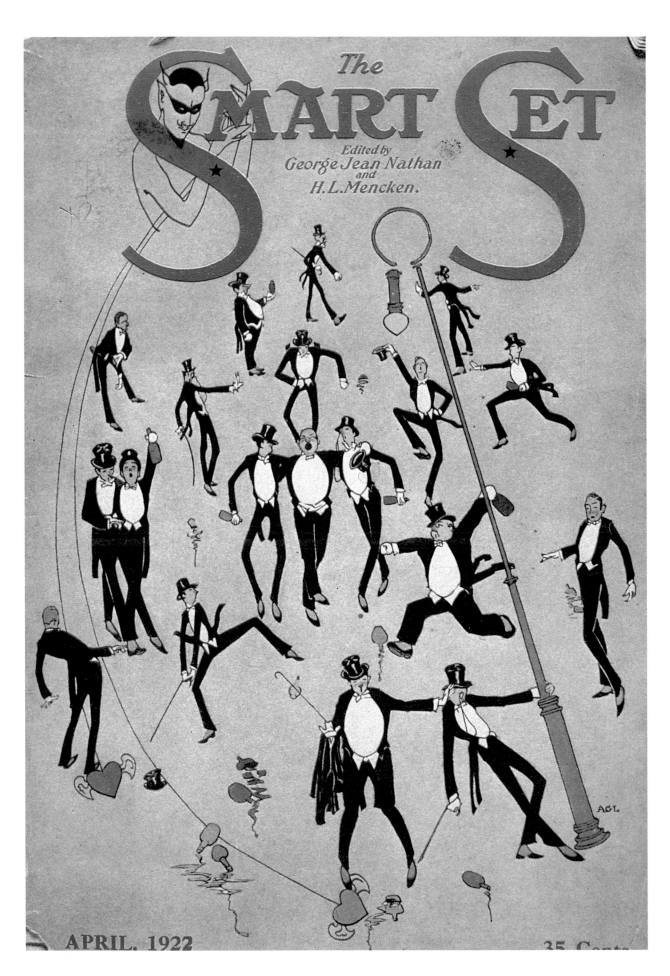

OPPOSITE:

THE SMART SET

APRIL 1922

ARTIST: "AGL"

Cultural critics George Jean Nathan and

H.L. Mencken published the most trenchant—

if often scabrous—magazine of the age.

Its covers were equally acerbic.

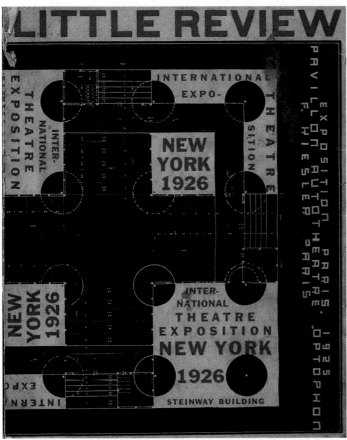

THE LITTLE REVIEW

SEPTEMBER 1926

ARTIST: FREDERICK KIESLER

The cover of this issue of one of the most

renowned small arts journals was a wraparound

schematic of Kiesler's design for a Paris exposition.

BROOM

FEBRUARY 1922

ARTIST: GORDON CRAIG

This magazine of the arts published "in Italy

by Americans" had stand-alone covers created by

the leading European avant-garde artists.

BALLYHOO

TAX NUMBER

APRIL
15 CENTS

GIVE!

Not all humor magazines had funny covers, because not all humor magazines were funny. The humor weekly actually began as a general watchdog of and commentator on the American scene. *Puck* and *Judge*, the leading late-nineteenth-century satiric tabloid periodicals, each

COVERING HUMOR

sided with different political par-

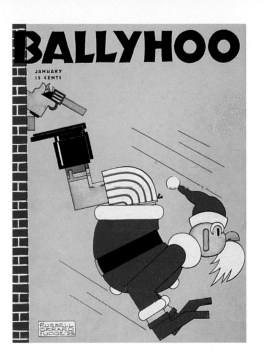

ties, the policies of which determined the stances that their covers and inside artists would take on issues of the day. By the turn of the century, both magazines began addressing more social controversies and their humor turned from acerbic to jesting. The third in this influential triumvirate, *Life*, was founded in 1883 by cartoonist John Ames Mitchell and published in an 8" by 10" magazine size. Although initially more rooted in social issues, by 1900 it turned its attention almost exclusively toward society and the arts. Around the same time, economical color printing allowed *Life* to brighten up its black-and-white covers, which became the most widely viewed comic tableau on the newsstand. *Life*, in fact, was the wellspring of the modern magazine cover. Artists such as James Montgomery Flagg, Coles Phillips, Norman Rockwell, John Held, Jr., and others who would become famous for their associations with other magazines began here. *Life*, and later a redesigned magazine-sized *Judge*, offered readers comic art, humorous vignettes, and stylish tableau covers. Some were clever ideas, others were genteel observations of the passing scene.

JUDGE

SEPTEMBER 1932

ARTIST: VERNON GRANT

After switching from its original tabloid format to a

smaller magazine, *Judge* used more poster-like covers.

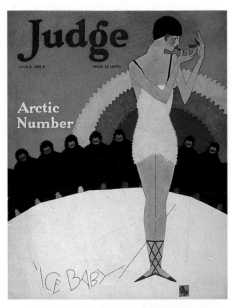

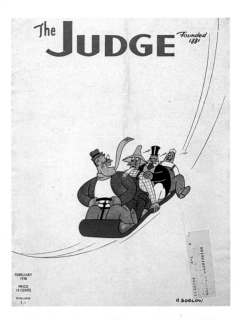

JUDGE

JULY 2, 1927

ARTIST: GARDNER REA

Gardner Rea provided *Judge* with some
of its most distinctive *moderne* artwork,
which was always witty and colorful.

JUDGE

FEBRUARY 1938

ARTIST: OTTO SOGLOW

Soglow was a biting social commentator
and the creator of *The Little King* cartoon.
Here he addresses the FDR regime.

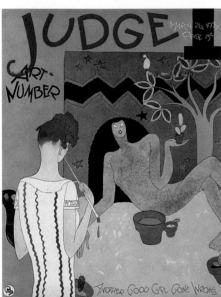

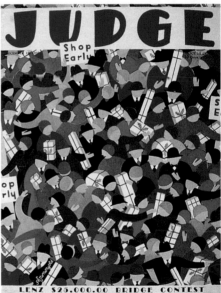

JUDGE

MARCH 26, 1927

ARTIST: GARDNER REA

Rea's lettering, like his fine-lined drawings,
was lighthearted and fun, but with an edge.

JUDGE

DECEMBER 12, 1931

ARTIST: A. CRONENGOLD

On first glance a decorative pattern,
on second a colorful mass of Christmas
shoppers on their annual ritual.

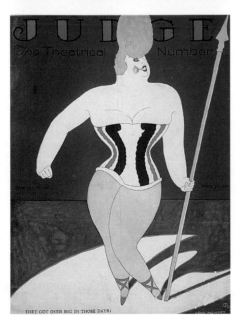

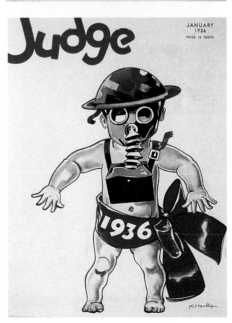

JUDGE

FEBRUARY 12, 1927

ARTIST: GARDNER REA

Poking fun at opera divas, Rea's drawing (drawn
"from memory") is at once charming and biting.

JUDGE

JANUARY 1936

ARTIST: F. HANLEY

Many magazine covers of the period portrayed the
New Year baby swathed in military paraphernalia.

Life

ECONOMY
NUMBER

JULY 2, 1925

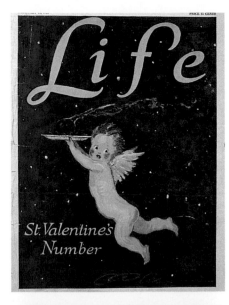

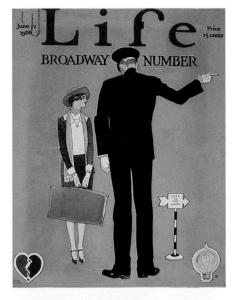

OPPOSITE:

LIFE

JULY 2, 1925

ARTIST UNKNOWN

Life, the long-running humor magazine, was a wellspring for the era's illustrations and a proving ground for artists...

LIFE

FEBRUARY 15, 1923

ARTIST: CHARLES DANA GIBSON

...Editor and illustrator C.D. Gibson contributed many covers for special issues.

LIFE

JUNE 17, 1926

ARTIST: GARRETT PRICE

Life's weekly issues were often general, but most times were devoted to a special theme, such as this "Broadway Number."

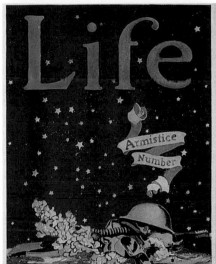

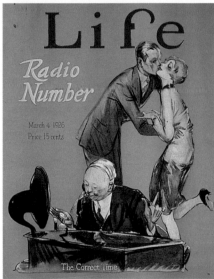

LIFE

NOVEMBER 8, 1923

ARTIST UNKNOWN

Covers were sometimes poignant representations of life's most tragic moments...

LIFE

MARCH 4, 1926

ARTIST UNKNOWN

Lighthearted but bound to the realist tradition, *Life*'s covers tried to capture a particular slice of life.

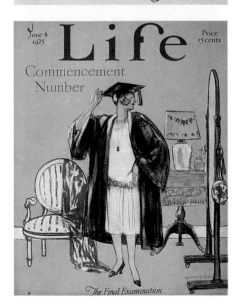

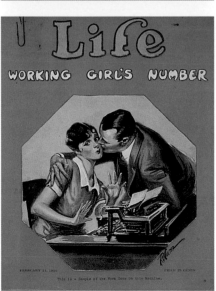

LIFE

JUNE 4, 1925

ARTIST: W. MORGAN

...And other times, they were vignettes or tableaux of life's triumphant events...

LIFE

FEBRUARY 11, 1926

ARTIST: R. AUSTER

...Sometimes, they were surprisingly sensitive regarding social conditions that would take decades to become issues.

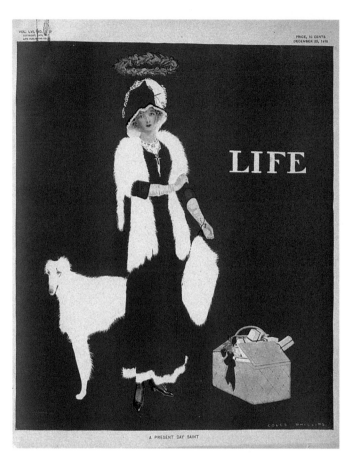

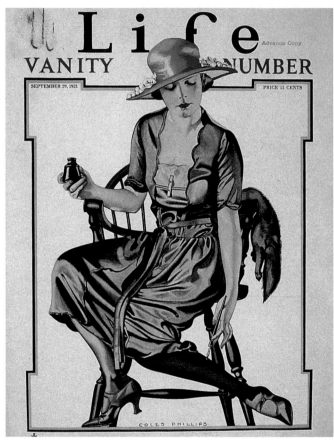

LIFE

DECEMBER 22, 1910

ARTIST: COLES PHILLIPS

Members of the *haute couture* set were depicted
by the leading renderers of the female form.

LIFE

SEPTEMBER 29, 1921

ARTIST: COLES PHILLIPS

Life had a long tradition of presenting
its vision of the ideal American woman.

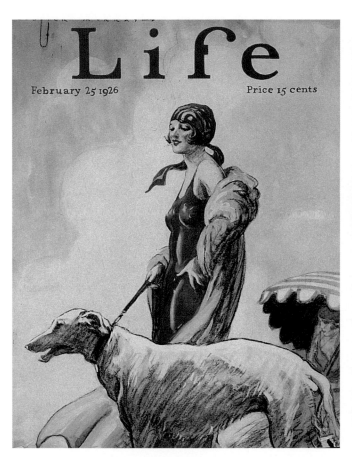

LIFE

FEBRUARY 25, 1926

ARTIST: WEBSTER MURRAY

...And these covers serve as a barom-
eter of styles, tastes, and fashions, at
least in cities like New York.

LIFE

APRIL 7, 1927

ARTIST: COLES PHILLIPS

Like most contemporary magazines,
Life was cognizant of the sales appeal
of fashionable women on its covers.

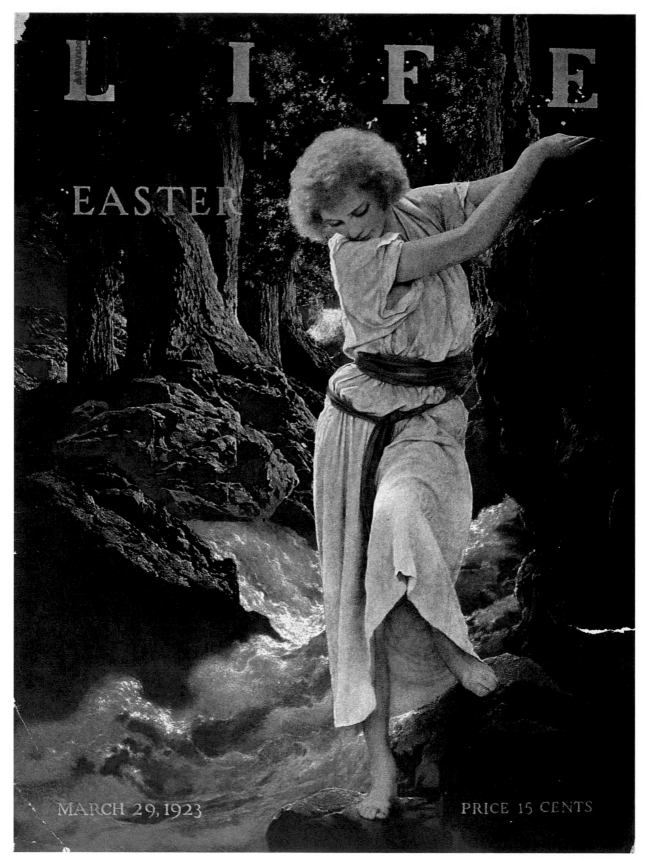

LIFE

MARCH 29, 1923

ARTIST: MAXFIELD PARRISH

Life is a veritable museum of popular art. Even today, its artists are considered the leaders of the golden age of illustration.

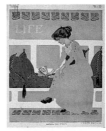 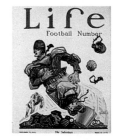

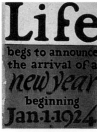 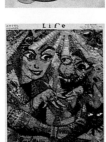 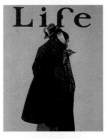 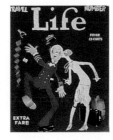 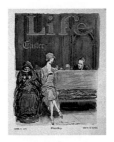 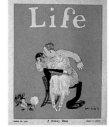

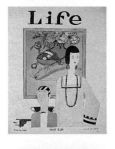 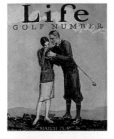 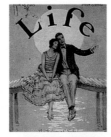 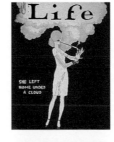 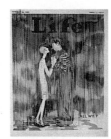 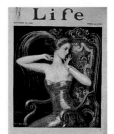

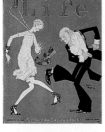 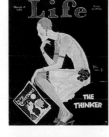 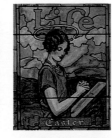 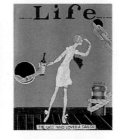 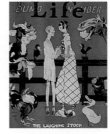 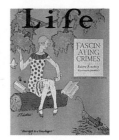

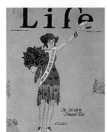 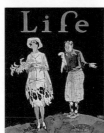 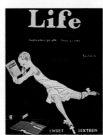 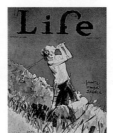 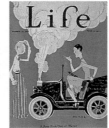 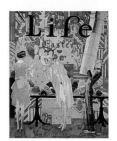

LIFE

FROM 1908 TO 1927

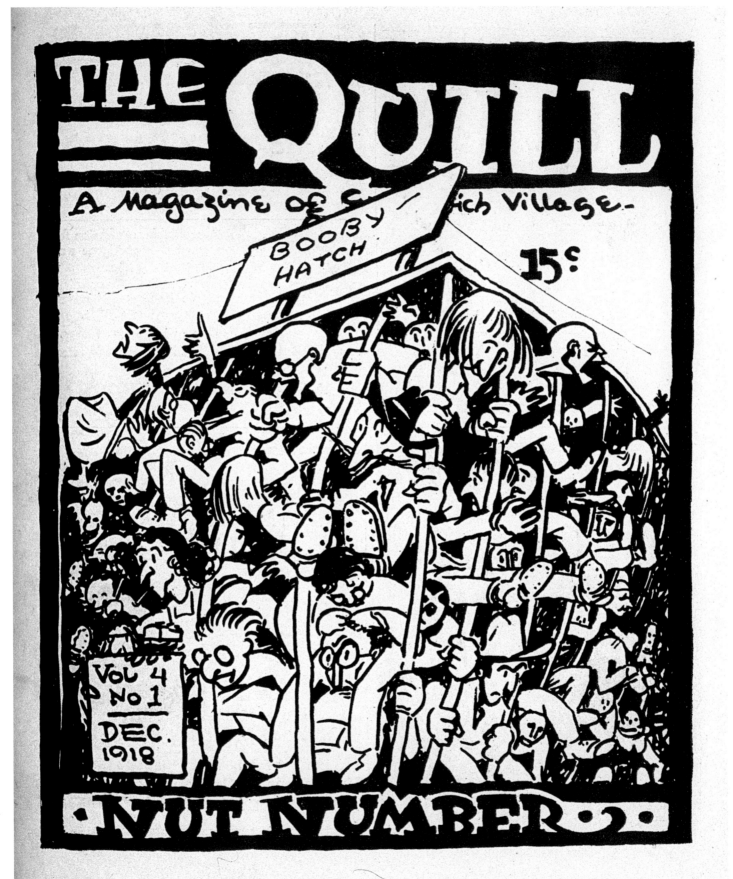

OPPOSITE:

THE QUILL

A MAGAZINE OF GREENWICH VILLAGE

DECEMBER 1918

ARTIST UNKNOWN

Greenwich Village was the bohemian capitol of
the United States, and its primary gazette expressed
the weird behavior of its inhabitants.

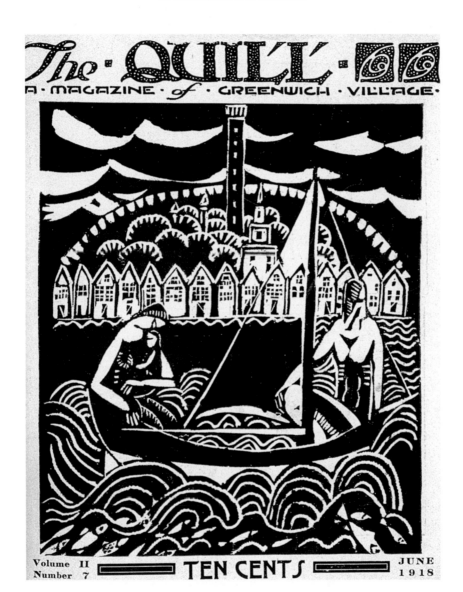

THE QUILL

A MAGAZINE OF GREENWICH VILLAGE

JUNE 1918

ARTIST UNKNOWN

The magazine provided a regular diet of humor and
cultural reportage; its covers suggested its diversity.

DELINEATOR

DITH WHARTON WILLIAM LYON PHELPS

ARGARET CULKIN BANNING OLGA MOORE

Fashion magazines of the late 1920s and 1930s incorporated many of the avant-gardisms that had been introduced on the covers of the progressive culture magazines, with an added touch of *haute couture* for good measure. It was the mission of these magazines to be on the crest of the new waves without being too far ahead. There-

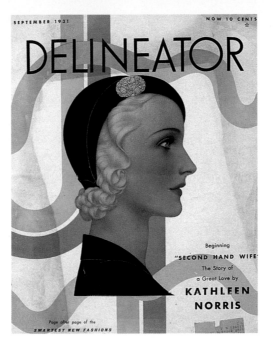

COVERING FASHION

fore, the fashion cover cally adventurous than The leaders were *Harper's* on the German *Der Bazar* as a "family" magazine War, and *Vogue*, which always fashion oriented. visual personas many was always more graphi- other magazines' covers. *Bazaar*, which was based and initially published shortly after the Civil began in 1892 and was Both had to reinvent their times over. In the 1920s,

Harper's Bazaar contracted with leading *art moderne* stylist Erté, and in the 1930s, with French posterist A. M. Cassandre to make covers that defined their era. Likewise, Benito was the graphic stylist for *Vogue's* "high-deco" cover art. While some explicitly evoked a fashion or beauty theme, a large number were art for art's sake, with only a nod to fashion. Other fashion and beauty magazines—notably the *Delineator, Modern Priscilla,* and *Charm*—were graphically reserved, using stylized representations of contemporary women. In 1938, Paul Rand introduced collage covers on *Apparel Arts,* a unique photographic approach that helped change the look of fashion cover design in the decades to follow.

OPPOSITE:

VOGUE

JULY 1938

ARTIST: MIGUEL COVARRUBIAS

The surreal setting against which bathing
suits are presented in this issue prefigures
surrealistic fashion photography.

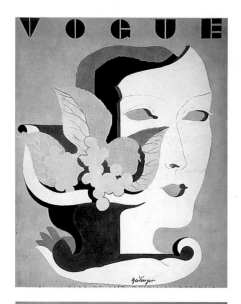 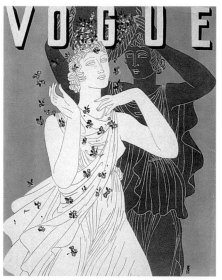

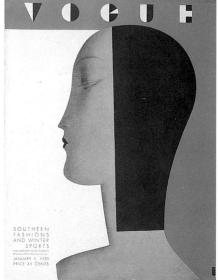 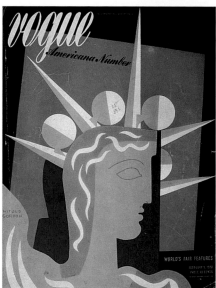

VOGUE

SEPTEMBER 1930

ARTIST: ZEILINGER

Vogue's covers were rooted in the
art moderne aesthetic, which perfectly
represented beauty and fashion.

VOGUE

JANUARY 4, 1930

ARTIST: EDUARDO BENITO

Benito's covers of streamlined
female forms gave an unmistakable
aura to *Vogue*'s covers for a decade.

VOGUE

FEBRUARY 1, 1932

ARTIST: EDUARDO BENITO

Spring may be far off, but Benito's
personification of spring fashion
positions the magazine in the future.

VOGUE

FEBRUARY 1, 1939

ARTIST: WITOLD GORDON

This Statue of Liberty with a crown
made of the Trylon and Perisphere
ties fashion to the World's Fair.

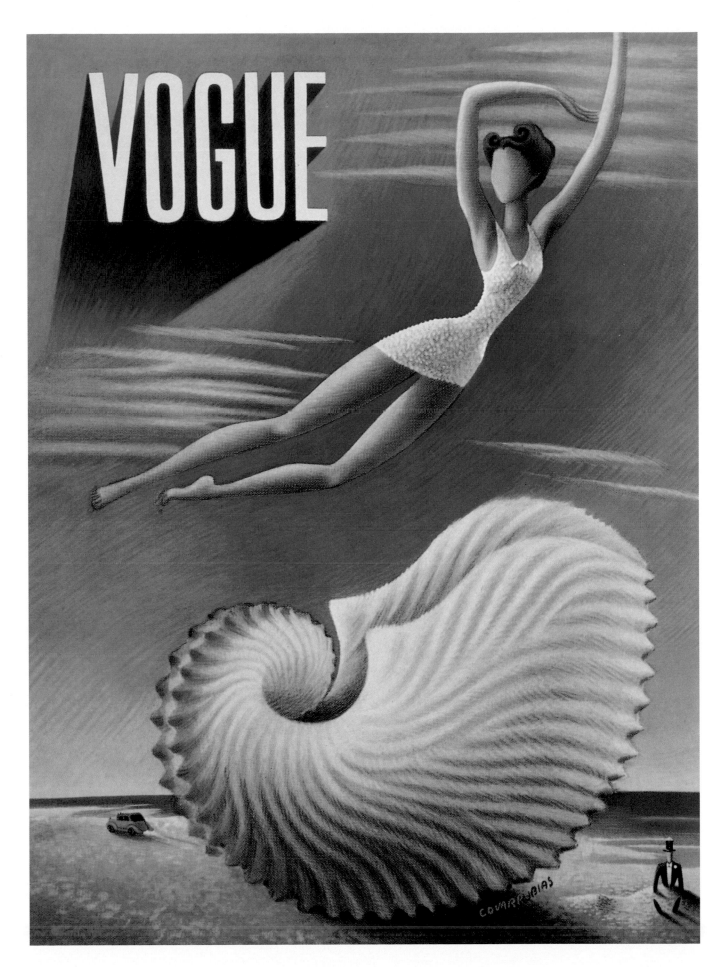

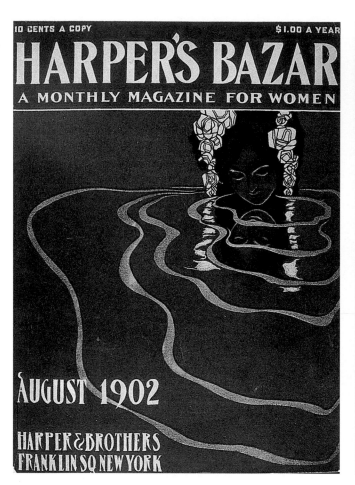

HARPER'S BAZAR

AUGUST 1902

ARTIST: GEORGE F. KERR

The cover for this early issue (note
only one "a" in Bazar) is influenced
by European art nouveau.

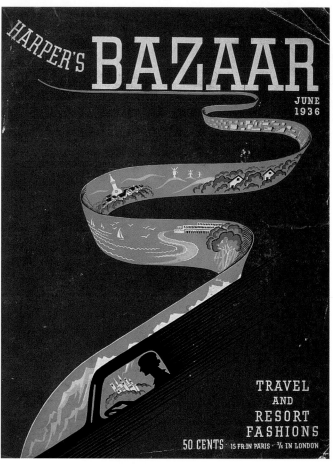

HARPER'S BAZAAR

JUNE 1936

ARTIST: ERTÉ

For the "Travel and Resort" issue,
the designer snakes a speeding automobile
around the vast expanse of the cover.

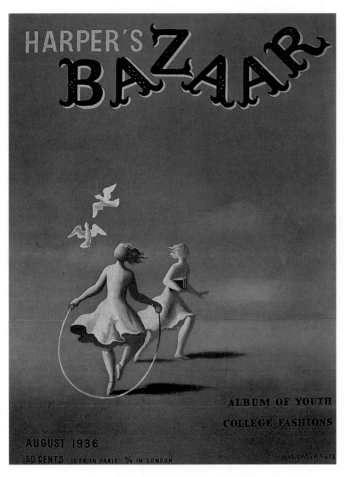

HARPER'S BAZAAR

AUGUST 1936

ARTIST: A.M. CASSANDRE

This surreal landscape suggests a
period of innocence. The circus lettering
in the logo suggests a time of play.

HARPER'S BAZAAR

APRIL 1938

ARTIST: A.M. CASSANDRE

To symbolize the spring wedding season,
Cassandre projects a cherub through the sky;
in its wake, a bridal veil cuts the darkness.

Harper's BAZAAR

OCTOBER 1938

Beauty

A. M. CASSANDRE 38

OPPOSITE:

HARPER'S BAZAAR

OCTOBER 1938

ARTIST: A.M. CASSANDRE

Fashion magazines introduced surrealism to American
culture as a fresh way to address beauty and style.

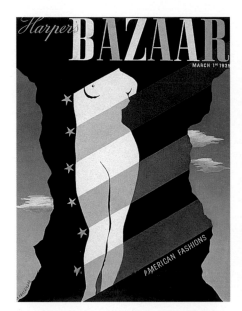

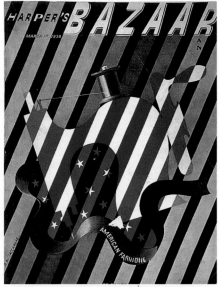

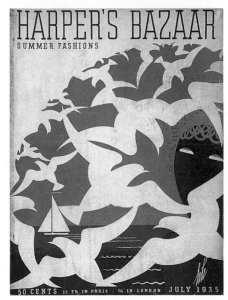

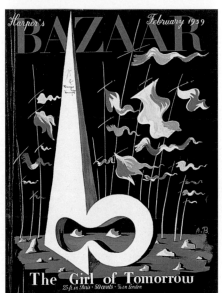

HARPER'S BAZAAR

MARCH 1939

ARTIST: A.M. CASSANDRE

Sculptural figures set against surreal
backdrops provided an ethereal context
for presenting contemporary dress.

HARPER'S BAZAAR

JULY 1935

ARTIST: ERTÉ

In this design, any direct relationship to
clothes or makeup is overshadowed by the
artist's representation of summer itself.

HARPER'S BAZAAR

MARCH 1938

ARTIST: A.M. CASSANDRE

To illustrate an issue on American
fashions, the artist cleverly transforms the
American flag to a symbolic pattern.

HARPER'S BAZAAR

FEBRUARY 1939

ARTIST: ALEXEY BRODOVITCH

Here the artist transforms the 1939
World's Fair icon, the Trylon and Perisphere,
into a mask for "the Girl of Tomorrow."

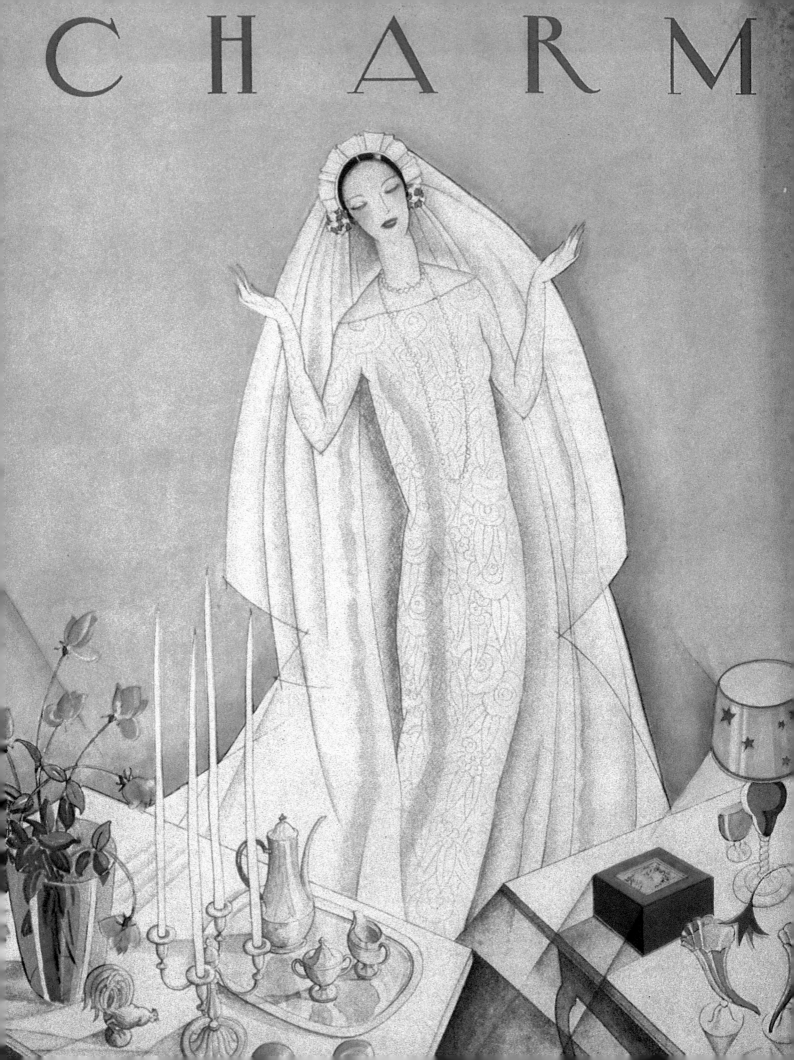

CHARM

OPPOSITE:

CHARM

MAY 1926

ARTIST: HARRIE WOOD

In contrast to Cassandre's bridal symbol, this
handsome rendering is decidedly more literal.

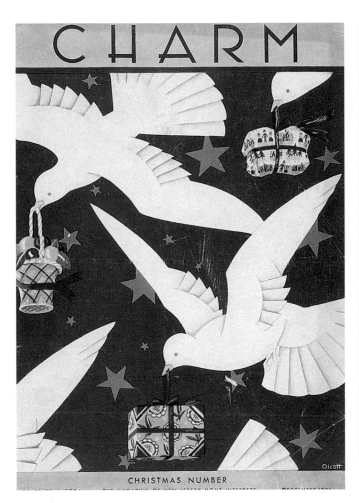

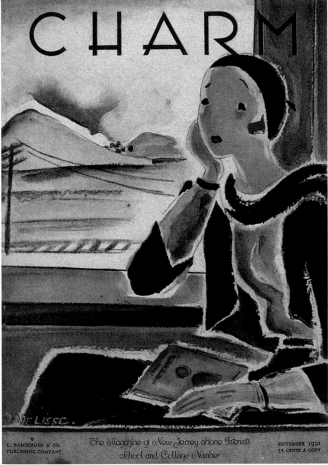

CHARM

DECEMBER 1931

ARTIST: LUCY G. OLCOTT

Nothing could be more to the point for
Christmas than doves of peace bearing gifts.

CHARM

SEPTEMBER 1930

ARTIST: MELISSE

This impressionistic watercolor represents
Charm's primary audience of "career girls."

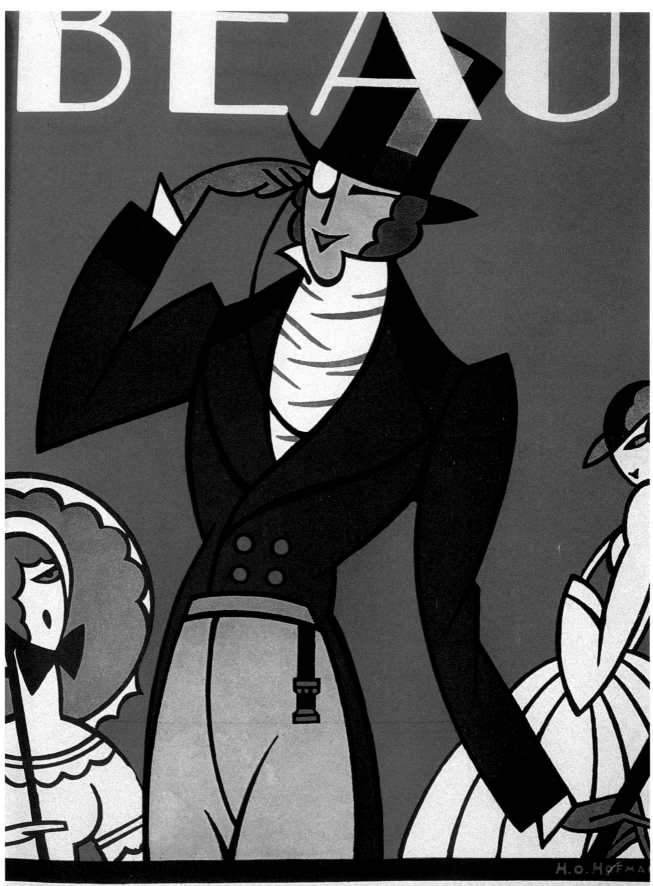

BEAU

OPPOSITE:

BEAU

OCTOBER 1926

ARTIST: H.O. HOFMAN

Beau, the Man's Magazine, was devoted
to the "comforts and luxuries of living."

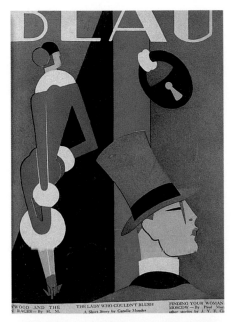

BEAU

NOVEMBER 1926

ARTIST: H.O. HOFMAN

The covers suggest the upper crust of this leisure
set and their superior relationship to women.

BEAU

JULY 1927

ARTIST: H.O. HOFMAN

The principles of cubist and futurist
art were adapted to forge the magazine's
distinctive visual persona.

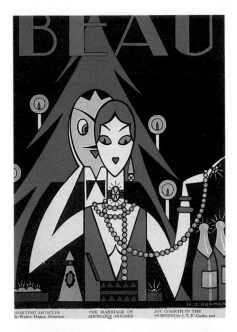

BEAU

JULY 1927

ARTIST: H.O. HOFMAN

Beau stylishly celebrated the bon vivant—the
man of means and the prince of extravagance...

BEAU

OCTOBER 1927

ARTIST: THORNDIKE

...At the same time, some of its covers took
sly comic stabs at fashions and mores, such
as this jab at the emaciated look.

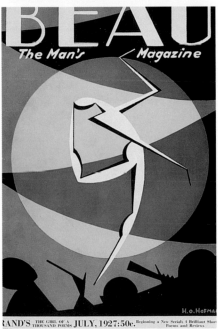

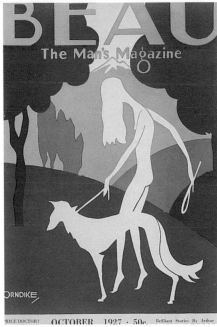

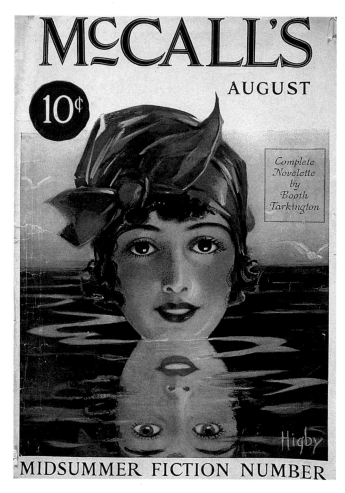

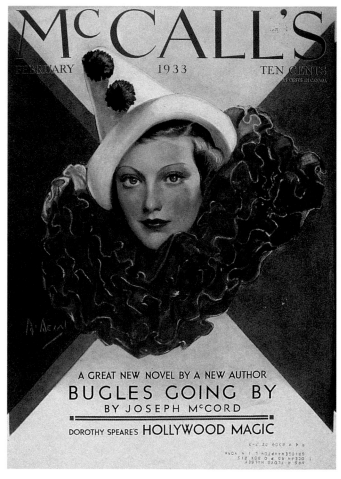

McCALL'S

AUGUST 1922

ARTIST: HIGBY

Not all fashion magazines were solely
devoted to fashion or beauty. *McCall's* wanted
to be the woman's cultural resource.

McCALL'S

FEBRUARY 1933

ARTIST: NEYSA MORA MCMEIN

Decades later, the magazine promoted
beauty through its cover art and a wide range
of other social articles inside.

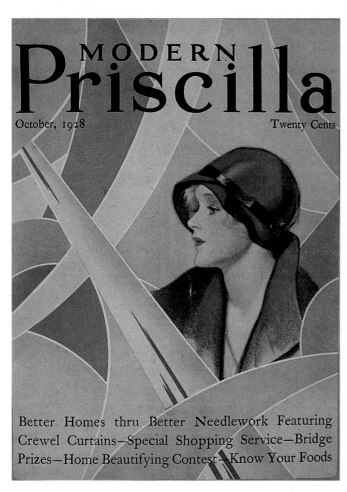

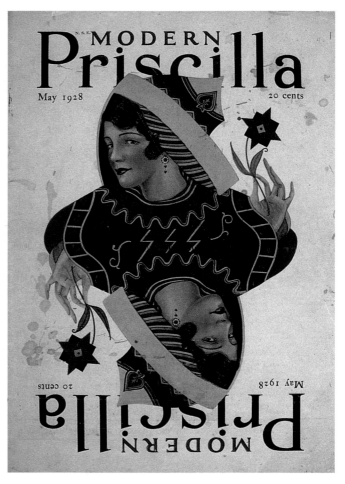

MODERN PRISCILLA

OCTOBER 1928

ARTIST: HELEN C. CARLSON

Combining "Modern" and "Priscilla"

seems to imply the elevation of the average

women over the commonplace...

MODERN PRISCILLA

MAY 1928

ARTIST UNKNOWN

...But the magazine was modern in style only.

The covers borrowed certain modernistic conceits

to give the impression of contemporaneousness.

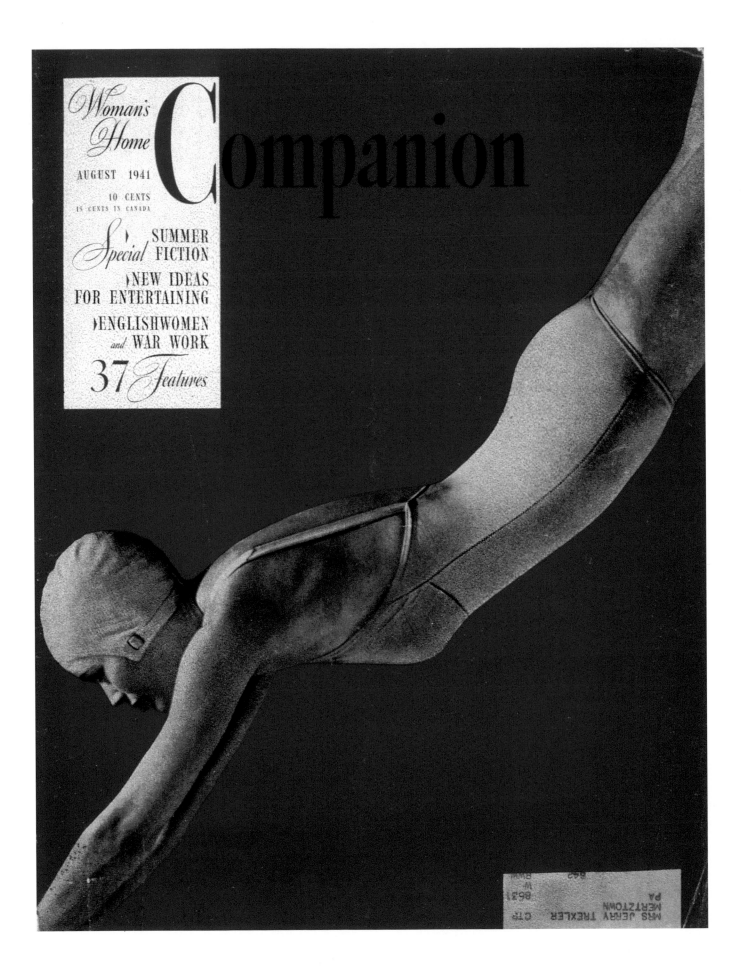

Woman's Home **Companion**

AUGUST 1941

10 CENTS
15 CENTS IN CANADA

Special SUMMER FICTION

)NEW IDEAS FOR ENTERTAINING

)ENGLISHWOMEN *and* WAR WORK

37 Features

OPPOSITE:

WOMAN'S HOME COMPANION

AUGUST 1941

ARTIST UNKNOWN

(taken from a photograph)

At certain periods, this magazine was devoted more to fashion
than lifestyle. This cover is a startling fashion statement.

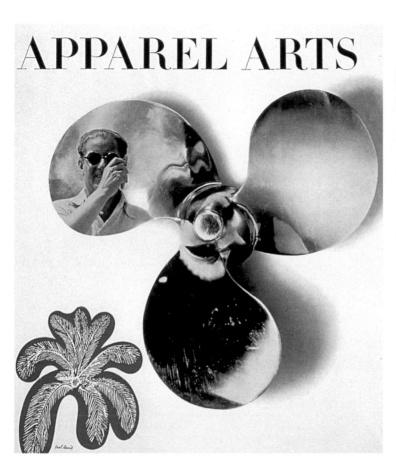

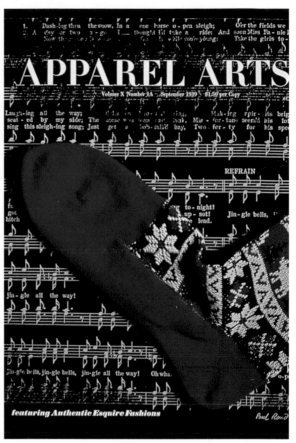

APPAREL ARTS

AUGUST 1939

ARTIST: PAUL RAND

Magazine covers really became modern in the
late 1930s when Paul Rand expanded the limits
of illustration to include photomontage.

APPAREL ARTS

SEPTEMBER 1939

ARTIST: PAUL RAND

The covers for this men's fashion magazine
did not rely on tired clichés, but rather
on new visual ideas born at the Bauhaus.

In 1924, an editorial in the American Medical Association's magazine *Hygeia* argued that *Physical Culture* magazine was "an outstanding example of the money that is to be made from catering to ignorance." The attack was aimed specifically at the Macfadden Publishing Company's flag-

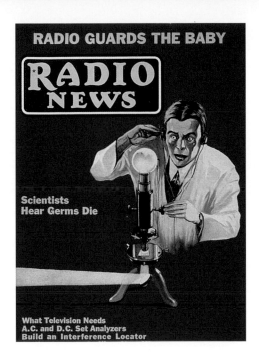

ship magazine, which began in 1899 and took the unique position that exercise and diet could cure any illness. More- over, it prematurely fought prudery, gluttony, drugs, alcohol, tobacco, and the use of corsets. Articles offered "proven" ways of thwarting the body's nat- ural and unnatural decline while its covers celebrated the beauty of the fit and healthy human form. From the 1920s onward self-help and how-to magazines addressed a variety of pop- ular subjects. The *Home Craftsman* provided instructions on home repairs, *Home Craft* offered schematic plans for building cars, boats, and appliances, and *Radio News* extolled this mass medium's virtues while it promoted amateur radio experiments. Most of these how- to magazine covers were ideal visions of everyday life set in real-life contexts. Conversely, covers for *Popular Science* and *Popular Mechanix* were more extraordinary in suggesting visions of America's industrial future. Exquisitely rendered paintings proposed improbable projections of how transport would look twenty years hence. These futuristic icons some- how didn't jive with magazines devoted to making household mechanics more accessible.

OPPOSITE: **STRENGTH** APRIL 1931 ARTIST: E.K. BERGEY ABOVE: **RADIO NEWS** JULY 1932 ARTIST: MOREY

PHYSICAL CULTURE

NOVEMBER 1926

ARTIST: JAY WEAVER

Macfadden wanted his covers to be
recruitment posters in the war against
gluttony and sloth...they succeeded.

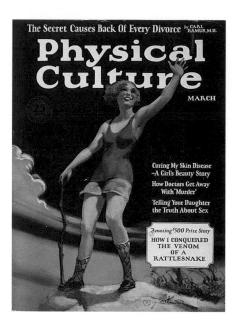

PHYSICAL CULTURE

MARCH 1927

ARTIST: JAY WEAVER

Macfadden's ideal woman was thin
and muscular; conventional renderings
of femininity were not to be found.

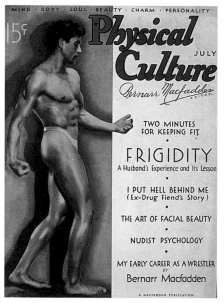

PHYSICAL CULTURE

JULY 1933

ARTIST: ALLAN A. REITER

While the design changed frequently, the covers
always depicted healthy men and women.

PHYSICAL CULTURE

25 CENTS

AUGUST

A COMPLETE NOVEL BY ARNOLD BENNETT

IN THIS ISSUE

CAN DIET PREVENT CANCER?

BY SIR ARBUTHNOT LANE

A MACFADDEN PUBLICATION

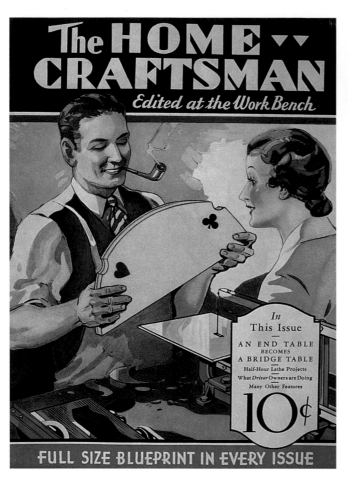

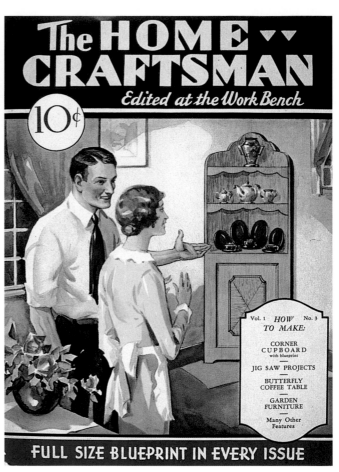

THE HOME CRAFTSMAN

1931 (MONTH NOT PRINTED)

ARTIST UNKNOWN

The cover for volume 1, number 1, of this pocket-sized magazine set the tone for subsequent issues...

THE HOME CRAFTSMAN

1931 (MONTH NOT PRINTED)

ARTIST UNKNOWN

...Depicting Mrs. Average (the same couple is always shown) admiring Mr. Average's handiwork.

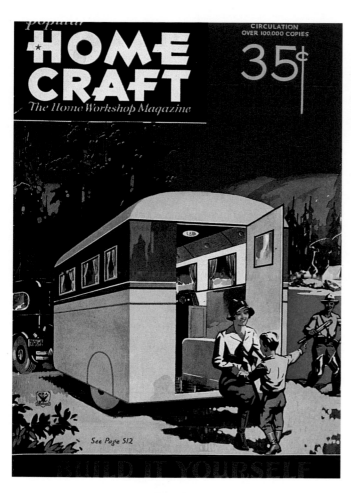

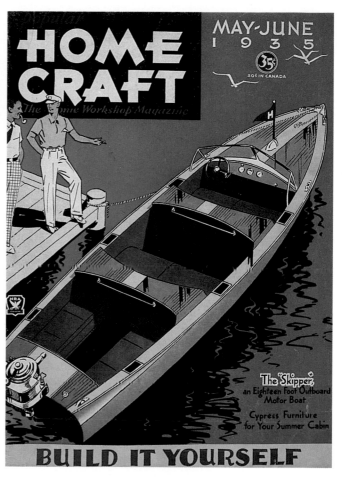

HOME CRAFT

MARCH/APRIL 1934

ARTIST UNKNOWN

By following the easy build-it-yourself instruc-
tions, anyone can build a mobile camper.

HOME CRAFT

MAY/JUNE 1935

ARTIST UNKNOWN

Using a more schematic rendering method, *Home
Craft*'s covers celebrated American ingenuity.

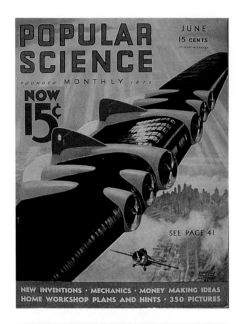

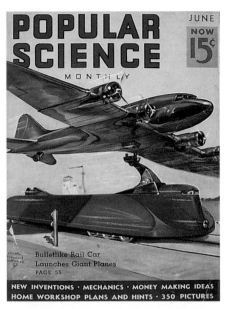

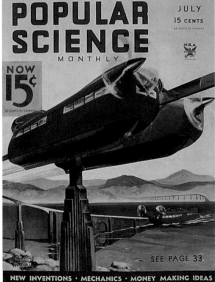

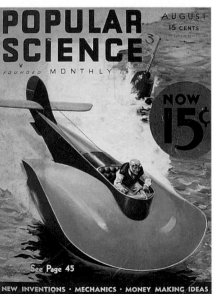

POPULAR SCIENCE

JUNE 1933

ARTIST: EDGAR FRANK WITTMACK

During the 1930s, *Popular Science* offered its readers
a diet of science fiction and mechanical know-how.

POPULAR SCIENCE

JULY 1934

ARTIST: EDGAR FRANK WITTMACK

On the heels of the Great Depression, these covers
suggested the great potential of the Machine Age.

POPULAR SCIENCE

JUNE 1937

ARTIST: EDGAR FRANK WITTMACK

These covers epitomized American streamline
as applied to all manner of fast vehicle.

POPULAR SCIENCE

AUGUST 1937

ARTIST: EDGAR FRANK WITTMACK

Absurd contraptions were so convincingly rendered
that even the most ridiculous seemed plausible.

POPULAR
SCIENCE
MONTHLY
Mechanics & Handicraft

BOMBS vs.
WARSHIPS
PAGE 52

OCTOBER
15¢

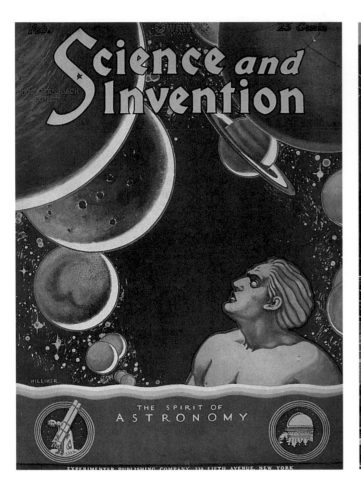

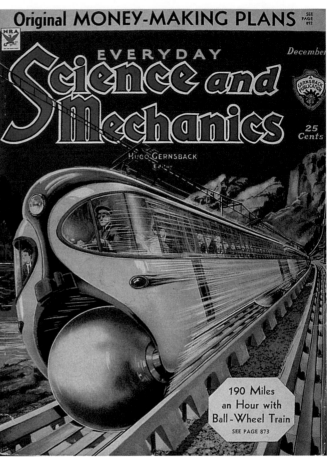

SCIENCE AND INVENTION

FEBRUARY 1929

ARTIST: HILLIKER

In an attempt to increase interest in the sciences,

covers were often rendered in a storybook fashion.

EVERYDAY SCIENCE AND MECHANICS

DECEMBER 1933

ARTIST UNKNOWN

The key to an effective cover was to convincingly

render all the details of the reality within the fantasy.

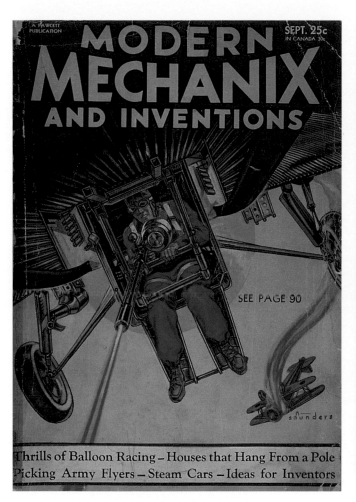

MODERN MECHANIX AND INVENTIONS

SEPTEMBER 1932

ARTIST: NORMAN SAUNDERS

Norman Saunders, the most popular of
all the how-to/fantasy illustrators, could also
convincingly render action and suspense.

MODERN MECHANIX AND INVENTIONS

FEBRUARY 1934

ARTIST: NORMAN SAUNDERS

The amazing thing about these covers, as
was the case with this gyroscope monorail car,
is that fiction was not too far from truth.

The Masses

JUNE
1916
10 CENTS

Glory

It would appear that political magazines benefit from strong poster-like covers, but not all of them take advantage of the polemical graphics that have been indelibly linked to political movements and causes. Many of the most strident political magazines had covers laden with typographic "billboards" that advertised key stories and themes within. Others went the poster route, and used benign graphics that express little if anything of the magazine's content. The most striking covers, however, are those that graphically reveal the ideological nature of the magazine. From its hand-scrawled logo to its grease-crayon depictions of an array of political events and ideas, the covers for *Revolt* reinforce the fact that this is a journal of

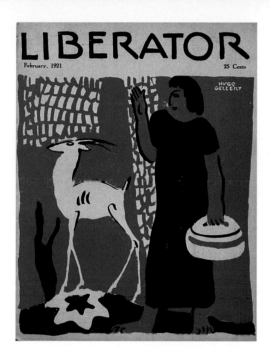

radical thought. Likewise covers for *The Workers Monthly, A Communist Magazine* are angry images that show capitalist oppression of the working class. Borrowing their cover format from the leading turn-of-the-century European political publications, *Simplicissimus* and *L'Assiette au Beurre*, the *Masses* and *New Masses* altered their logos to be consistent with the expressionistic renderings on their covers. This model was copied by other, smaller political journals and evolved into a rather timeworn convention. In 1938, Paul Rand designed covers for *Direction* using photo collage, expressive typography, and other modern graphic methods that shifted the focus from the cartoon to graphic design.

OPPOSITE:

THE WORKERS MONTHLY

DECEMBER 1925

ARTIST: B. CHAPER

This cover commemorating the 1905
workers' uprising in Czarist Russia echoes
the increasing unrest in America.

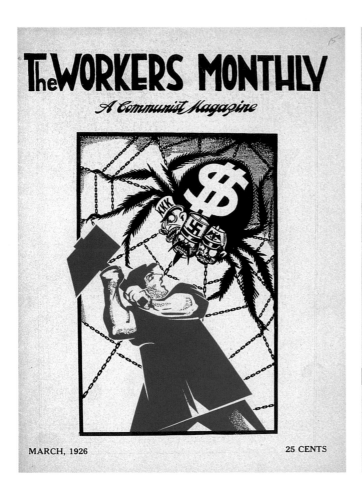

THE WORKERS MONTHLY

MARCH 1926

ARTIST UNKNOWN

The rough-hewn look of the logo and
the hard-edged political cartoon are typical
of covers for political magazines.

THE WORKERS MONTHLY

AUGUST 1926

ARTIST: ELLIA

These polemical covers spoke to those
who understood the plight of the worker
and the tyranny of management.

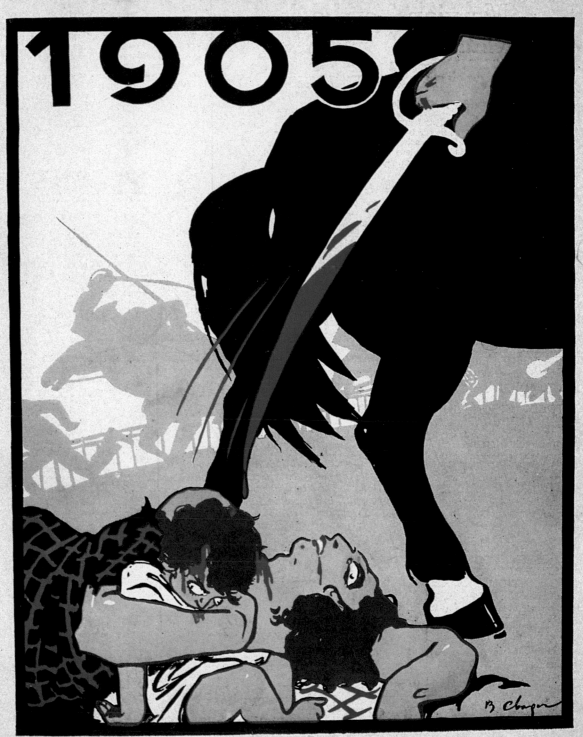

The WORKERS MONTHLY

1905

DECEMBER, 1925

25 CENTS

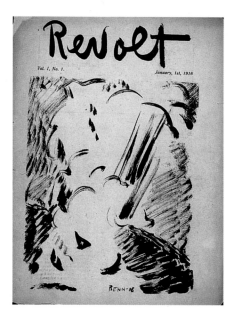

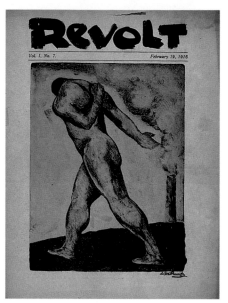

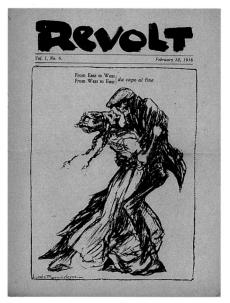

REVOLT

JANUARY 1, 1916

ARTIST: BENNING

The few brush strokes in this drawing of a battle-field blast echo the ad hoc lettering in the logo.

REVOLT

FEBRUARY 19, 1916

ARTIST: A. WALKOWITZ

Covers for *Revolt* portrayed men and women as being totally controlled by corrupt forces.

REVOLT

FEBRUARY 12, 1916

ARTIST: LOUIS RAEMAEKERS

Raemaekers was a master of depicting human suffering and military horror.

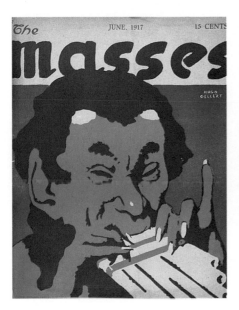

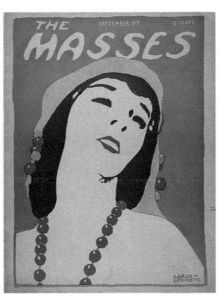

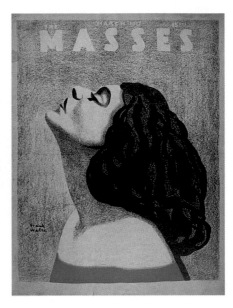

THE MASSES

JUNE 1917

ARTIST: HUGO GELLERT

A forum for socialists, syndicalists,
and libertarians, the *Masses* was
concerned with politics and culture.

THE MASSES

SEPTEMBER 1917

ARTIST: CARLO LEONETTI

Not all its covers were polemical or
even partisan in tone; as these reveal, many
belied the serious political content.

THE MASSES

MARCH 1917

ARTIST: FRANK WALTZ

The artists were allowed an equal say
in editorial content, and many preferred
to exhibit art for its own sake.

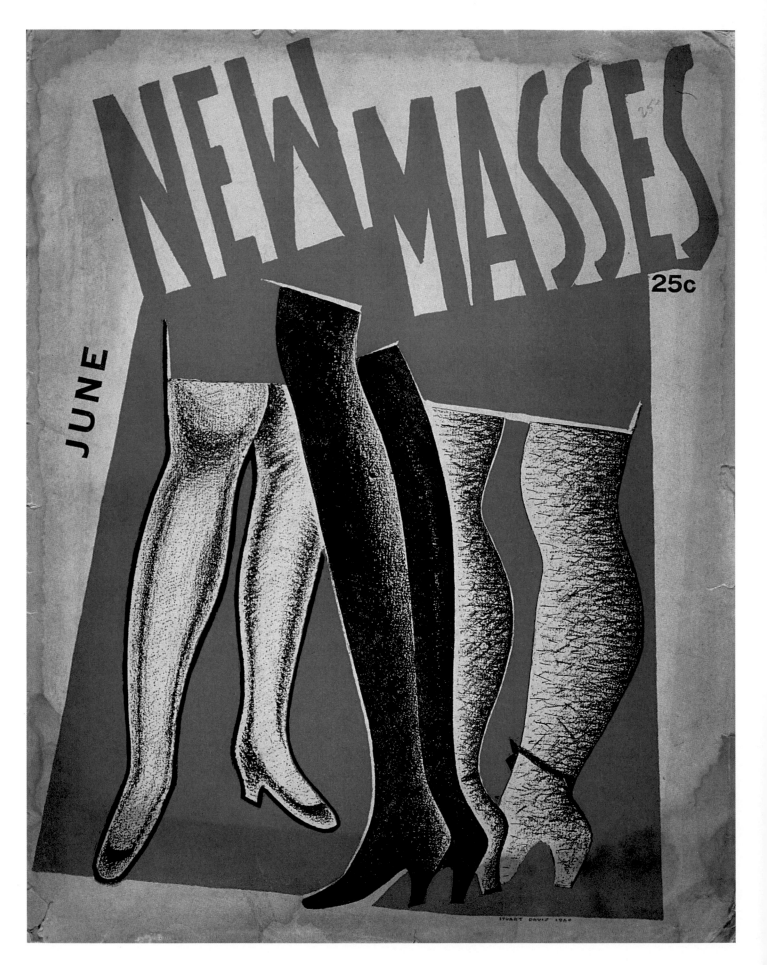

NEW MASSES

JUNE

25c

OPPOSITE:

NEW MASSES

JUNE 1926

ARTIST: STUART DAVIS

During World War I, the *Masses* became
the *Liberator*, which ceased after a few years.
In its wake, *New Masses* was born.

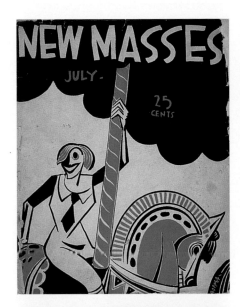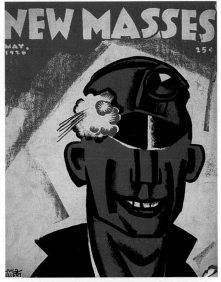

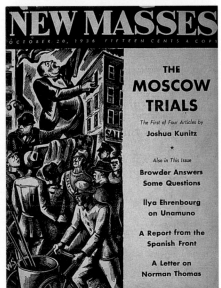

NEW MASSES

JULY 1926

ARTIST: WILLIAM GROPPER

Covers for the first issues of *New
Masses*, like the *Masses* before it, were
alternately prosaic and polemic.

NEW MASSES

JANUARY 5, 1937

ARTIST: HUGO GELLERT

By the 1930s, the weekly *New Masses'* size was
reduced and its covers were more polemical.

NEW MASSES

MAY 1926

ARTIST: HUGO GELLERT

The large format and flat colors made this
the perfect venue for poster-like covers.

NEW MASSES

OCTOBER 20, 1936

ARTIST: WILLIAM SANDERSON

Lithography crayon and woodcut were
the common black-and-white media and
came to typify the "leftist" drawing style.

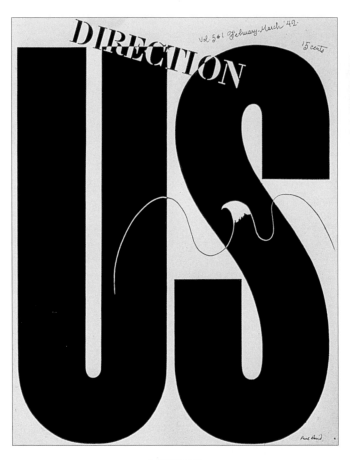

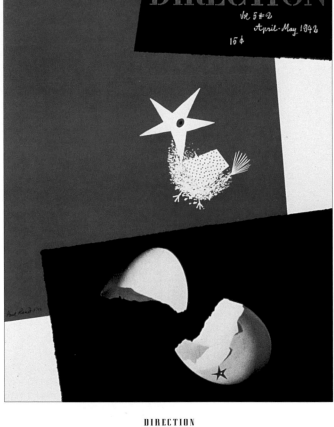

DIRECTION

FEBRUARY/MARCH 1942

ARTIST: PAUL RAND

Covers for this political/cultural magazine were revolutionary

in its modern marriage of type and image.

DIRECTION

APRIL/MAY 1942

ARTIST: PAUL RAND

Rand applied the principles of modern art—influenced

by De Stijl, constructivism, and the Bauhaus.

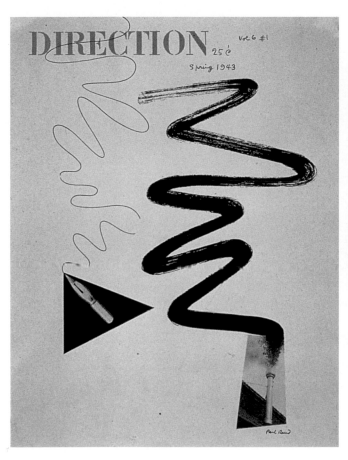

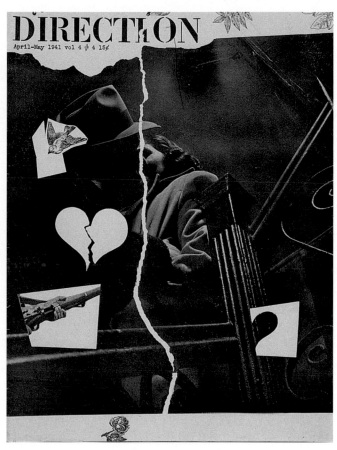

DIRECTION

SPRING 1943

ARTIST: PAUL RAND

Negative space—emptiness—was a striking counterpoint
to the overly rendered conventional covers.

DIRECTION

APRIL-MAY 1941

ARTIST: PAUL RAND

Simple drawings and photography were combined
to enhance the power of a political statement.

apr May 40

America's Machine Age, the period of industrial retooling and modernity between the late 1920s through the 1930s, is visually chronicled on the covers of the scores of magazines devoted to business and industry. From the *Standard Oil Bulletin,* the publicity organ of this mammoth

COVERING INDUSTRY

oil company, to *Fortune,* Henry Luce's testimonial to American capitalism, broadly referred to as Cap- cover graphics in a style italist realism portray industry as the bulwark of the nation, the key to both its power and security. Though varied, the imagery —and the symbology—of industry leads to one con-

PM

clusion: The factory is a monument as culturally significant to America as the great cathedrals in Europe or the pyramids in Egypt. While not all busi-

ness magazine covers were so overt—the advertising industry tried various means to express the power of advertising from Greco-Roman sculptures to exotic designs—the vast majority of magazines sought to lionize business. In contrast to the political covers in which workers were martyrs of industrial oppression and profit mongering, covers for industry advocates presented them either as heroes doing the nation's most important work or as naturally dwarfed by the machinery that they so loyally served and serviced. The business magazine cover was a poster that both advanced the cause of free enterprise and recruited new soldiers to fill the ranks of exalted capitalism.

OPPOSITE: **PM** APRIL/MAY 1940 ARTIST: JOSEPH BINDER ABOVE: **PM** SEPTEMBER 1936 ARTIST: GUSTAV JENSEN

OPPOSITE:

MORE BUSINESS

MAY 1936

ARTIST: BRADBURY THOMPSON

This striking airbrush rendering is consis-
tent with the increased attention paid to the
medium during the streamline era.

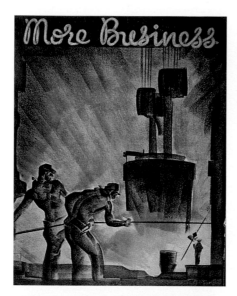

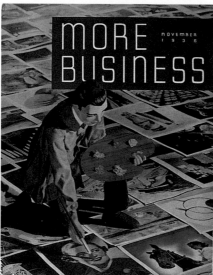

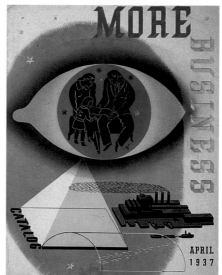

MORE BUSINESS

MARCH 1936

ARTIST: HORACE BRISTOL

The goal of this magazine was to help
industry increase business through modern
graphics in brochures and advertising.

MORE BUSINESS

DECEMBER 1936

ARTIST: COUTRÉ ERMAN

Three-dimensional art, like this
construction with the logo rendered in wire,
was becoming a popular form.

MORE BUSINESS

NOVEMBER 1936

ARTIST UNKNOWN

Covers were rendered by various artists representing
a wide range of contemporary approaches.

MORE BUSINESS

APRIL 1937

ARTIST UNKNOWN

Surrealism was also emerging as a means to
suggest more content in less available space.

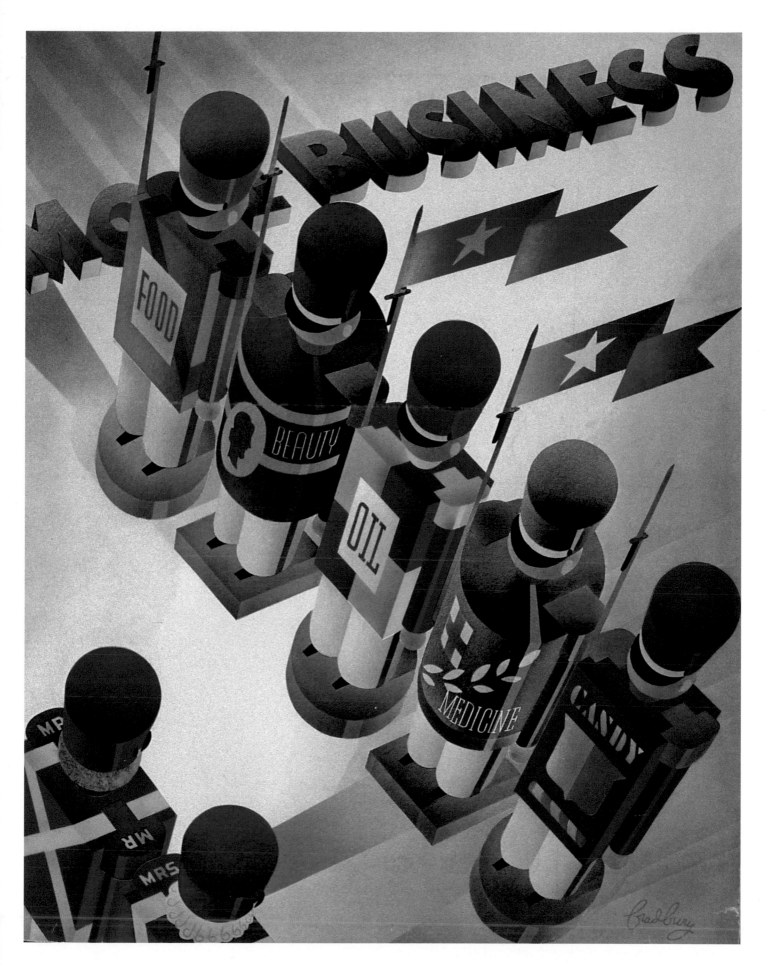

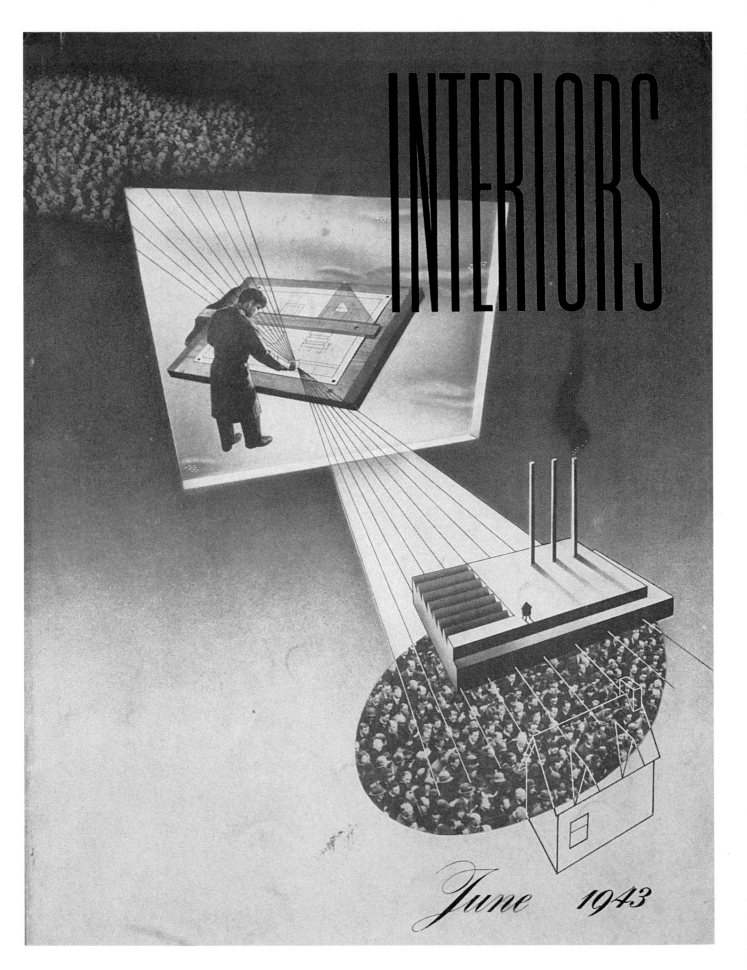

INTERIORS

June 1943

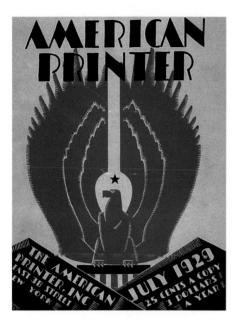

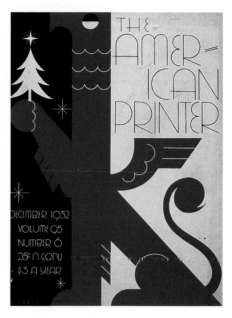

AMERICAN PRINTER

JULY 1929

ARTIST: L. MEYNARD MAYES

The eagle was the symbol for this
important trade magazine, here interpreted
in a typically heroic manner.

AMERICAN PRINTER

DECEMBER 1932

ARTIST: ALFRED "SACHA" MAURER

For this Christmas cover, the emblematic eagle
is transformed into a medieval griffin.

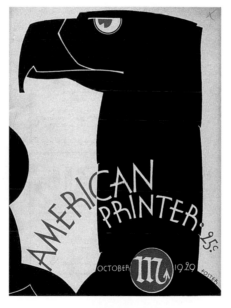

AMERICAN PRINTER

OCTOBER 1929

ARTIST: ROBERT FOSTER

The eagle is imbued with monumental qualities
through this stark black-and-white rendering
reminiscent of German trademarks.

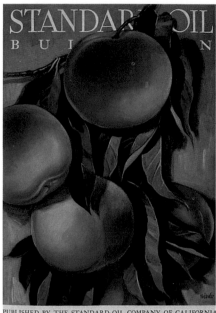

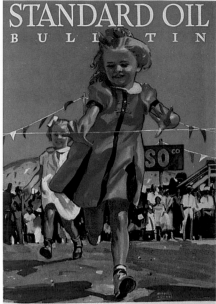

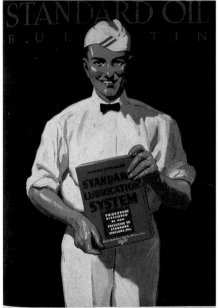

STANDARD OIL BULLETIN

AUGUST 1931

ARTIST: NÉHÉR

The covers for this digest-sized house organ
rarely referred to petroleum or its use.

STANDARD OIL BULLETIN

MAY 1932

ARTIST: MARRIS LOPAN

This clean service station
attendant is the only recognition of
Standard Oil's primary mission.

STANDARD OIL BULLETIN

OCTOBER 1937

ARTIST: MARRIS LOPAN

An idyllic setting in the California sunshine suggests
that Standard Oil is at one with its environment.

STANDARD OIL BULLETIN

JANUARY 1939

ARTIST: KEN SAMPFE

To announce Standard Oil's participation
in the 1939 San Francisco World's Fair
this cover shows the fair's centerpiece.

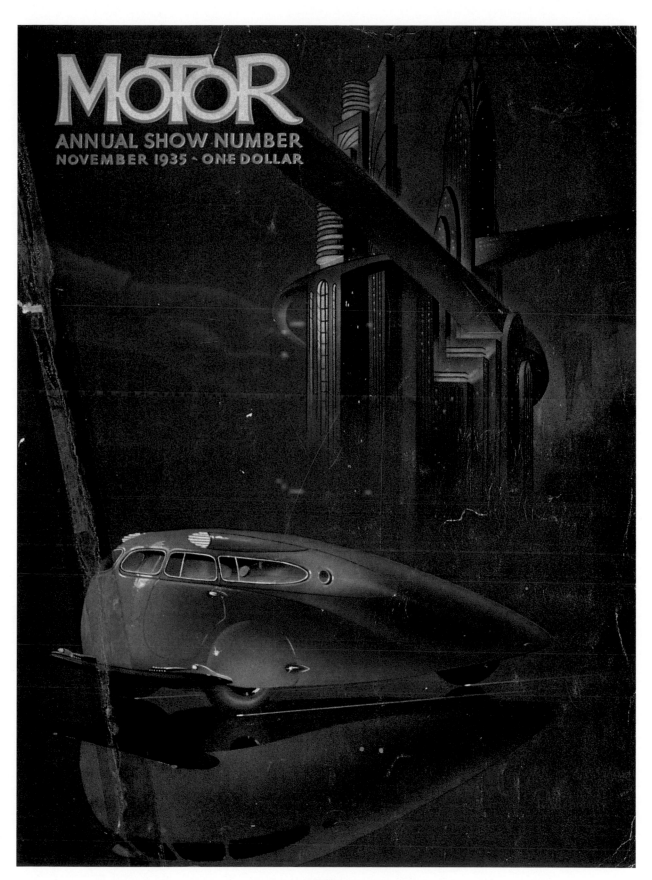

MOTOR

NOVEMBER 1935

ARTIST: H.C. RADEBAUGH

New York's annual automobile show is
where the most futuristic experimental cars,
like this Dymaxion auto, were unveiled.

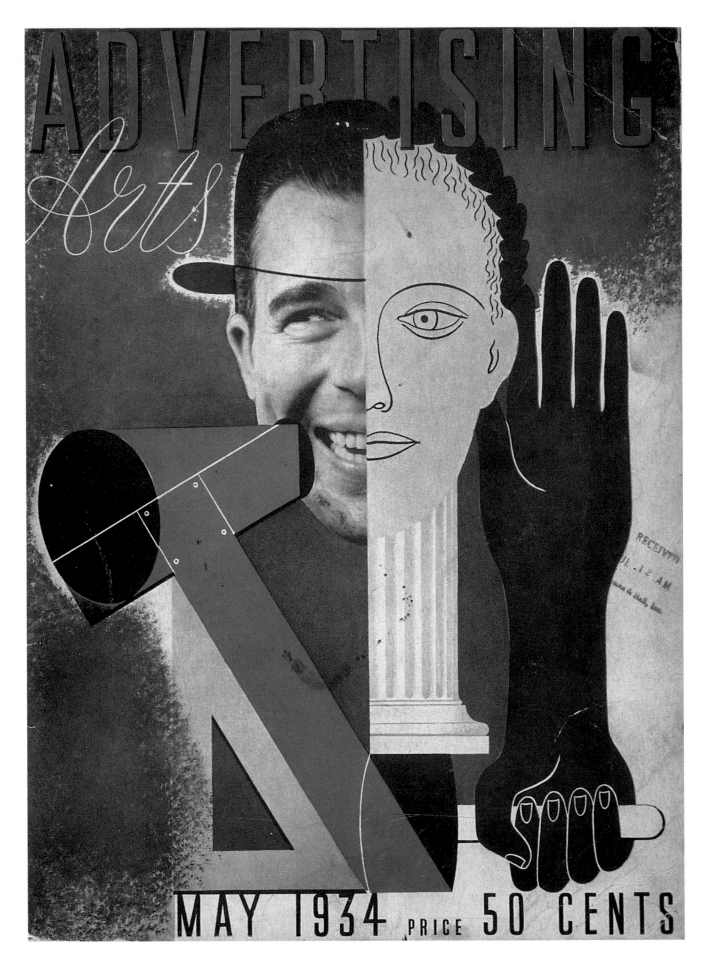

OPPOSITE:

ADVERTISING ARTS

MAY 1934

ARTIST: JOHN ATHERTON

Advertising Arts introduced modern graphic trends
and fashions to designers and advertising artists.

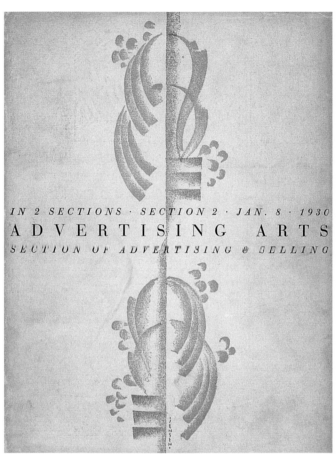

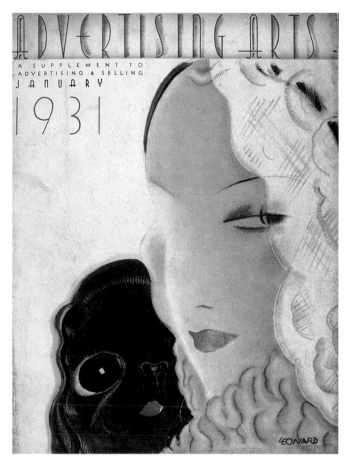

ADVERTISING ARTS

JANUARY 1930

ARTIST: GUSTAV JENSEN

The wildly variegated covers for this
magazine exhibited work by the leading
industrial artists and designers.

ADVERTISING ARTS

JANUARY 1931

ARTIST: LEONARD

From economical ornament to highly stylized
pastel renderings such as this, *Advertising Art*
was a highly popular art form.

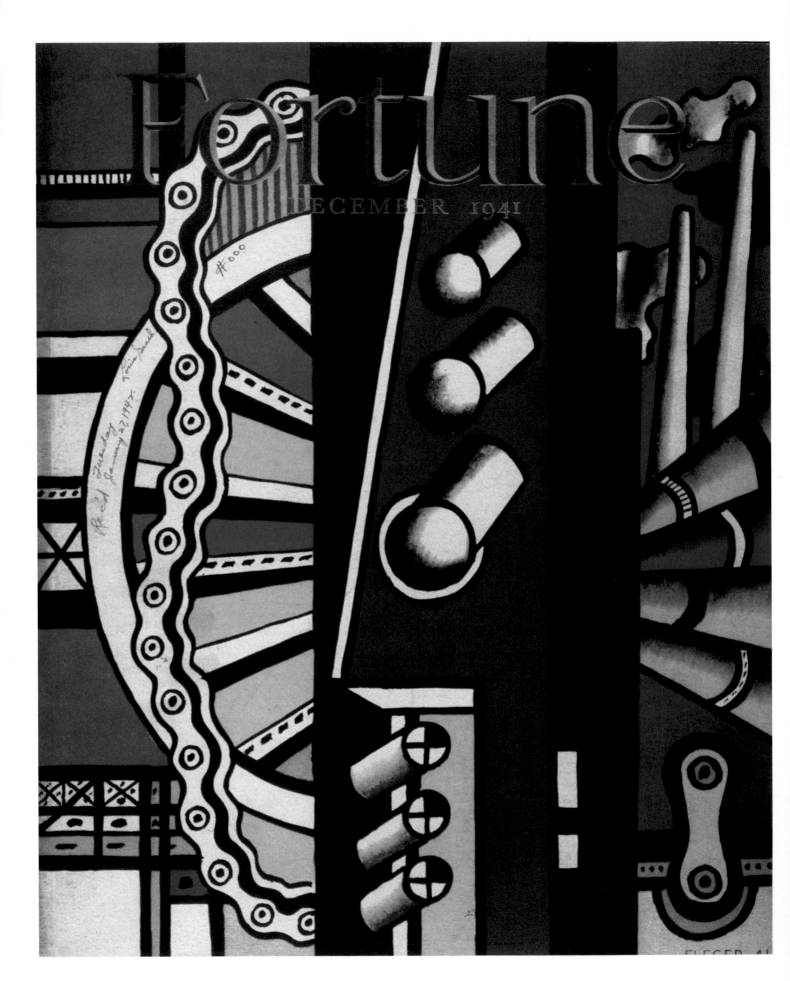

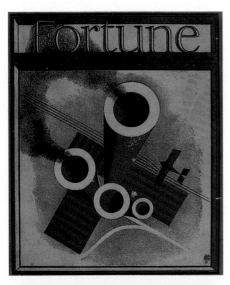

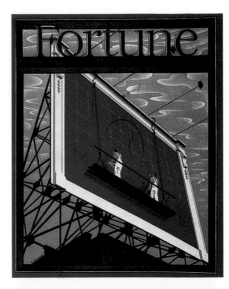

OPPOSITE:

FORTUNE

DECEMBER 1941

ARTIST: FERNAND LEGER

In this prefiguration of pop art, Leger's
Machine Age painting is a statement about
the marriage of art and industry.

FORTUNE

FEBRUARY 1932

ARTIST: PAOLO GARRETTO

Before factory chimneys were viewed
as environmental hazards, they were monu-
ments to American ingenuity.

FORTUNE

MAY 1937

ARTIST: A. PETRUCCELLI

This emblematic fragment symbolizes
one of the principal tools of marketing
before the age of television.

FORTUNE

DECEMBER 1938

ARTIST: A. PETRUCCELLI

Forging a Soviet emblem on the cover
of America's "Capitalist Tool" was a clever
way to introduce a story on Russia.

FORTUNE

MARCH 1938

ARTIST: S. CRANE

This chiaroscuro image of a
battleship is poised to introduce a story
on the status of the American navy.

FORTUNE

AUGUST 1935

ARTIST: HENRY STAHLHUT

Fortune covers often merely captured
an iconic element of the daily life of industry;
here a secretary takes dictation.

FORTUNE

MAY 1941

ARTIST: A. PETRUCCELLI

At first glance an abstract pattern,
this endless grid of army tents symbolizes
massive military mobilization.

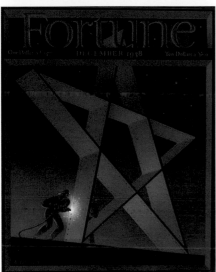

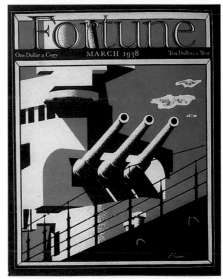

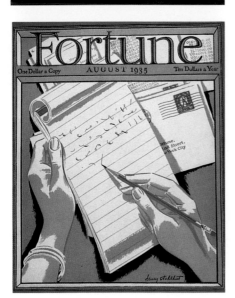

THE SATURDAY EVENING POST

Founded A.

Volume 211, Number 27

Dec. 31, '38

5c

ROBERT P. RUNSCH
BURLINGTON RD
BRIDGETON N. J.

1939

A TRACTOR STORY BY WILLIAM HAZLETT UPSON

The general interest magazine, the so-called family journal that appealed to a broad readership of men and women with news, gossip, service, and fiction, was the foundation of American periodical publishing until the 1960s when electronic media usurped its role with advertisers.

COVERING SOCIETY

At the same time, consumer fragmentation forever changed the demographics that governed publishing. But for decades prior—from the mid-nineteenth to the mid-twentieth century—magazines like *Harper's Weekly, Leslie's Weekly, The Saturday Evening Post, Collier's,* and later *Life* and *Look* chronicled contemporary American society and laid the groundwork for a popular history of the United States. After the turn of

the century, circulations greatly increased when it was discovered that magazines could be marketed inexpensively to the reader while passing the real costs on to the advertiser. Higher production values—including color printing—were a key purchasing incentive. The aesthetics of cover art attracted readers like bears to honey. The covers of general interest magazines were indeed general, yet reflected and sometimes dictated the social tenor of the nation. Mores and fashions were addressed through recurring ideal character types. Daily life was depicted through realistic renderings that presented a lily-white portrait of America. The general magazine cover advertised the magazine, and the American dream.

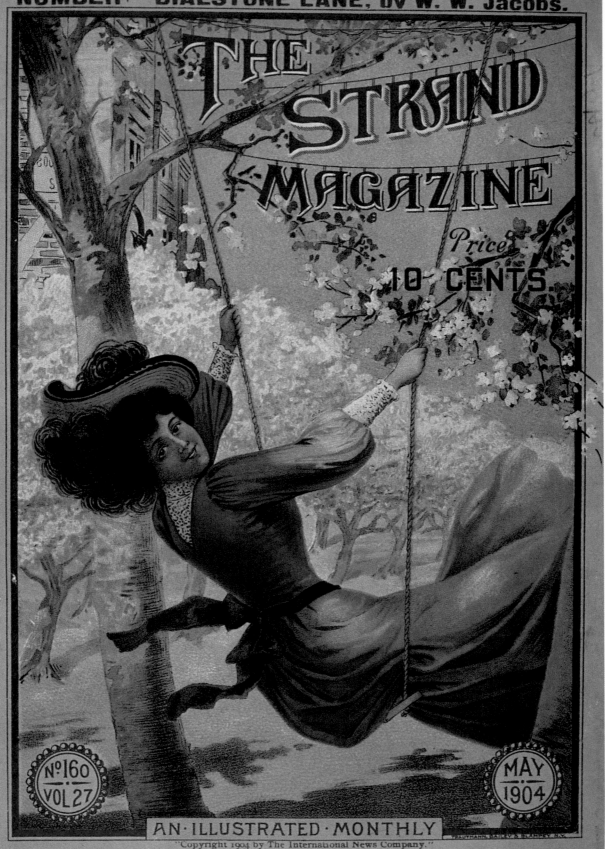

OPPOSITE:

THE STRAND

MAY 1904

ARTIST UNKNOWN

London's most popular magazine was also published
in the United States with similar Victorian-era
covers. This one shows a young Sarah Bernhardt.

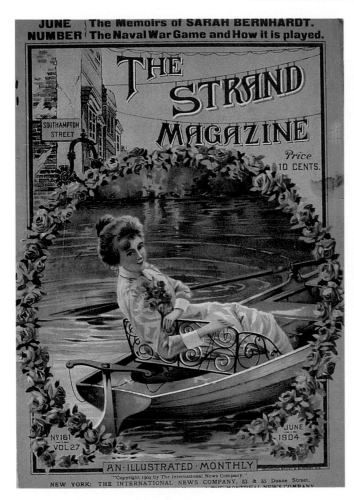

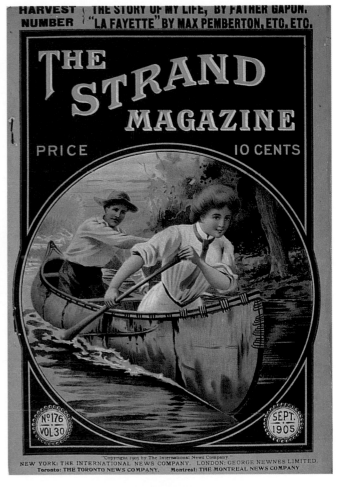

THE STRAND

JUNE 1904

ARTIST UNKNOWN

The logo hanging from the clothesline
was a clever touch signalling that this
was a magazine about city life.

THE STRAND

SEPTEMBER 1905

ARTIST UNKNOWN

Even proper urban dwellers needed
to get out into the wilderness from time
to time for a bit of adventure.

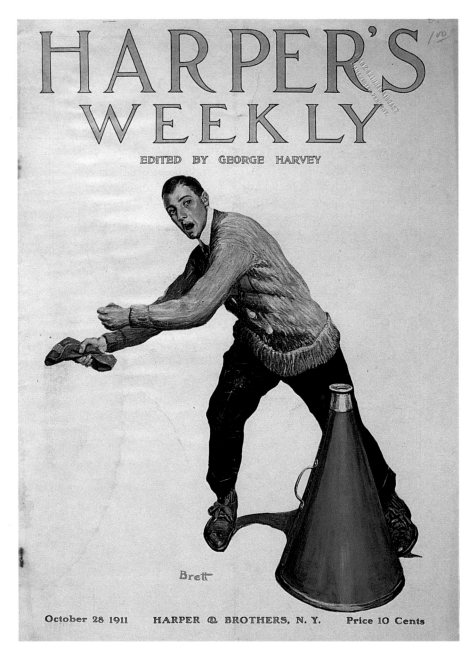

HARPER'S WEEKLY
FEBRUARY 7, 1914
ARTIST: MILTRED TILTON
Some covers, particularly this early
full-color example, simply gave the reader
pleasing artwork to enjoy.

HARPER'S WEEKLY
FEBRUARY 22, 1913
ARTIST: CHAS A. MACLELLAN
The down-home charm of many cover subjects
gave *Harper's Weekly* its mass-market appeal.

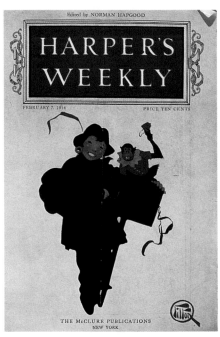

HARPER'S WEEKLY
OCTOBER 28, 1911
ARTIST: BRETT
Harper's Weekly was the first illustrated
American magazine. Its covers evolved from
detailed wood-engraved tableaux through
various styles and fashions.

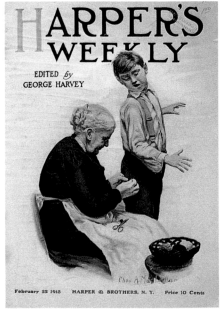

HARPER'S
WEEKLY
EDITED BY GEORGE HARVEY

HARPER'S WEEKLY
APRIL 20, 1901
ARTIST: W.A. ROGERS
Many of its covers during the late nine-
teenth century were strident political cartoons,
such as this attack on Tammany Hall.

HARPER'S WEEKLY
OCTOBER 19, 1912
ARTIST: WILLIAM H. FOSTER
This dramatic seafaring scene is an
illustration for one of the many pieces
of fiction published each issue.

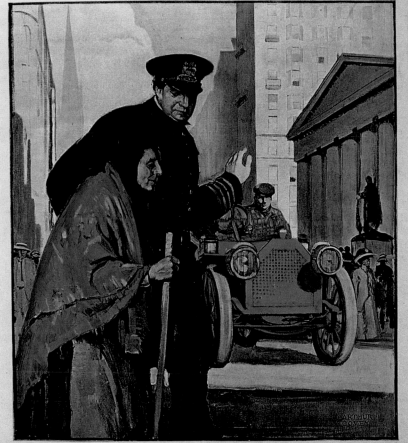

September 2 1911 HARPER & BROTHERS, N. Y. Price 10 Cents

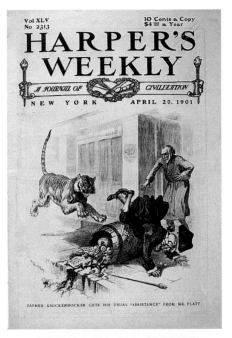

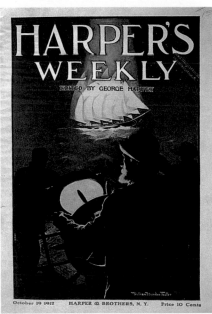

HARPER'S WEEKLY
SEPTEMBER 2, 1911
ARTIST: ARTHUR COVEY
Covers depicting the everyday lives of
ordinary people were interesting counterpoints
to conventionally accepted idyllic scenes.

The War In Pictures

MAY 11th
1918

Leslie's

Illustrated Weekly Newspaper

PRICE 10 CENTS

In Canada, 15 Cents

NOTICE TO READER

When you finish reading this magazine place in a one-cent stamp on this notice, mail the magazine, and it will be placed in the hands of our soldiers or sailors destined to proceed overseas.

NO WRAPPING—NO ADDRESS

"FOR GOD'S SAKE HURRY UP!"

CHOATE

★ Copyright, 1918, by Leslie's

OVER HALF A MILLION A WEEK

126

OPPOSITE:

LESLIE'S

MAY 11, 1918

ARTIST UNKNOWN

Though it was one of America's first
illustrated weeklies, *Leslie's* did not always
rely on pictorial illustration alone.

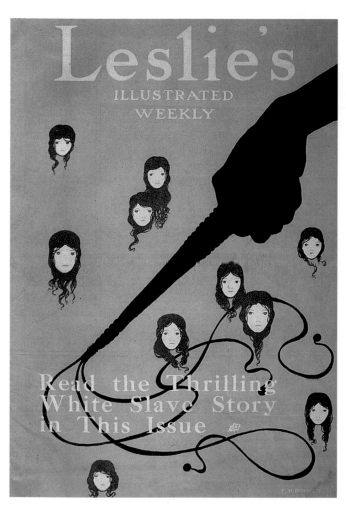

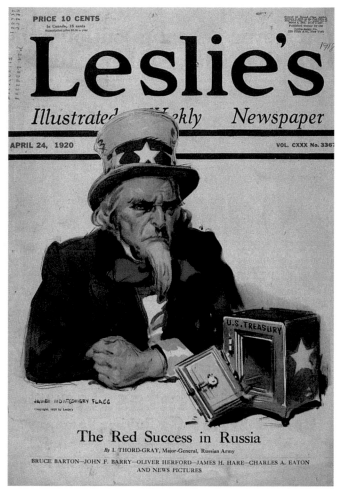

LESLIE'S

MAY 11, 1914

ARTIST: F.P. ROHUER

The menacing whip and floating decapitated
women's heads are a startling way to announce
this exposé of the white slave trade.

LESLIE'S

APRIL 24, 1920

ARTIST: JAMES MONTGOMERY FLAGG

Flagg used his emblematic rendition of Uncle
Sam (based on a self-portrait), popularized as a
recruitment poster, on many magazine covers.

OPPOSITE:

COLLIER'S

AUGUST 17, 1940

ARTIST: E.M. JACKSON

The patriotic fervor of *Collier's* is best illustrated

by this painter preparing to obliterate the logo.

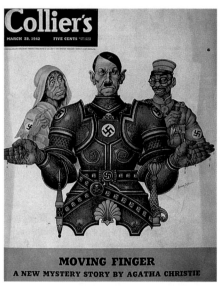

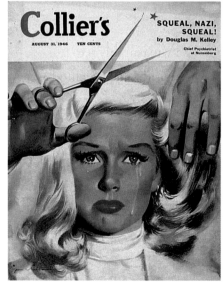

COLLIER'S

JULY 6, 1940

ARTIST: ALAN FOSTER

Elaborate gags were pegged to the

seasons rather than stories; this sculptural

illustration was common cover fare.

COLLIER'S

MARCH 28, 1942

ARTIST: ARTHUR SZYK

Collier's dates back to 1888 as a crusading

journal; in the 1940s, it aided the propaganda

war with scathing caricatures like this.

COLLIER'S

AUGUST 31, 1946

ARTIST: JON WHITCOMB

In the 1940s, mannerists like Jon Whitcomb—

with their idealizations of real life—were the

mainstays of editorial illustration.

COLLIER'S

JULY 1, 1933

ARTIST: ROBERT O'REID

Summer headwear was just one of

the many benign themes addressed on

the cover of this national weekly.

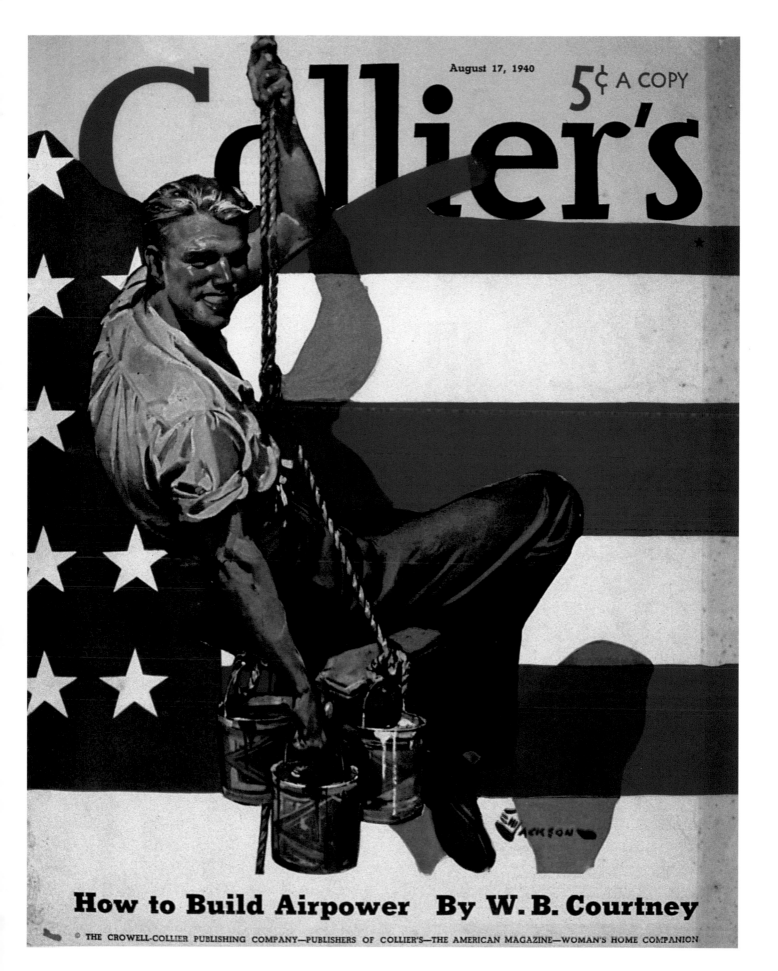

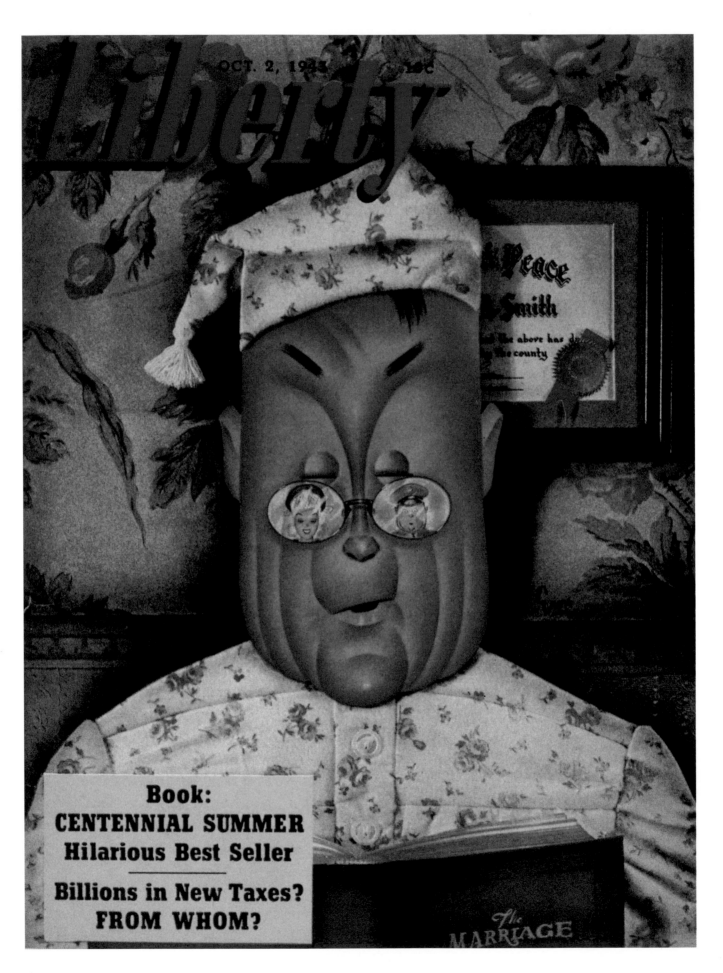

Liberty

OCT. 2, 1943

Book:
CENTENNIAL SUMMER
Hilarious Best Seller

Billions in New Taxes?
FROM WHOM?

OPPOSITE:

LIBERTY

OCTOBER 2, 1943

ARTIST UNKNOWN

When Bernarr Macfadden purchased *Liberty* in
1931, he transformed it by combining the spunk of
the pulps and the verve of the general weeklies.

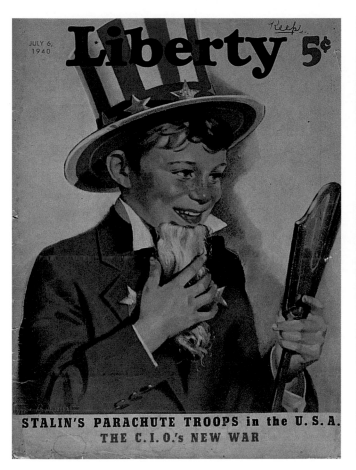

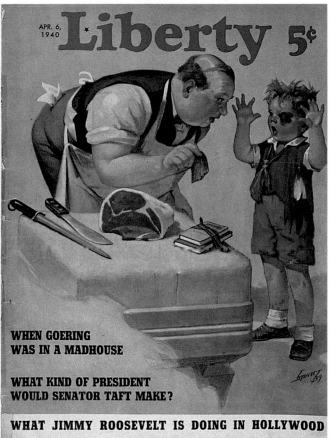

LIBERTY

JULY 6, 1940

ARTIST: WILL BRENNAN

Liberty's covers were designed to telegraph
a message quickly—just like its articles,
each of which came with an average suggested
reading time printed in the margin.

LIBERTY

APRIL 6, 1940

ARTIST: STUART

Quaint and humorous slices of life
were meted out as regular fare,
illustrated by a large stable of popular
comic and realistic illustration.

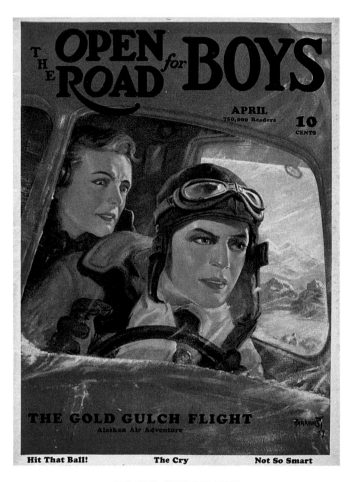

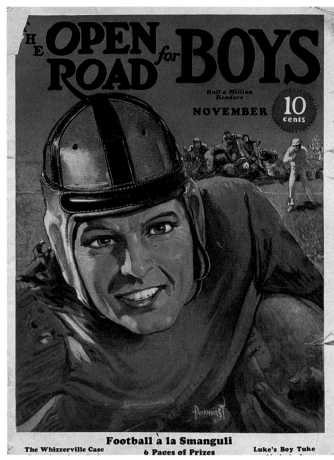

THE OPEN ROAD FOR BOYS

APRIL 1937

ARTIST: PARKHURST

This magazine for young boys published fiction

and nonfiction adventure and sports stories.

THE OPEN ROAD FOR BOYS

NOVEMBER 1935

ARTIST: PARKHURST

These close-cropped poses attracted the attention

and the imaginations of the young audience.

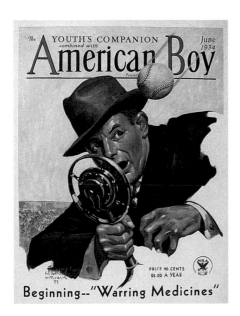

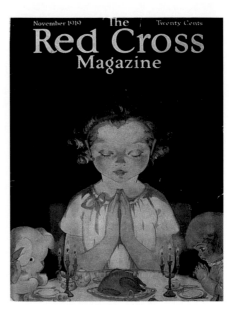

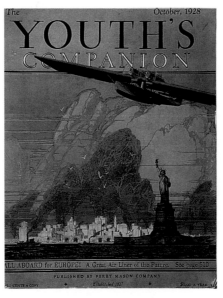

AMERICAN BOY

JUNE 1934

ARTIST: EDGAR F. WITTMACK

The same artist who rendered *Popular
Science* fantasies recorded the life of sports
figures and radio commentators.

RED CROSS MAGAZINE

NOVEMBER 1919

ARTIST: T.M. BEVANS

Although children were not the only cover
subjects, this celebration of Thanksgiving
is typical of the illustration style.

YOUTH'S COMPANION

OCTOBER 1928

ARTIST: P.B. PARSONS

Considering this magazine was aimed
at children, the graphics—from the logo to
the artwork—are highly sophisticated.

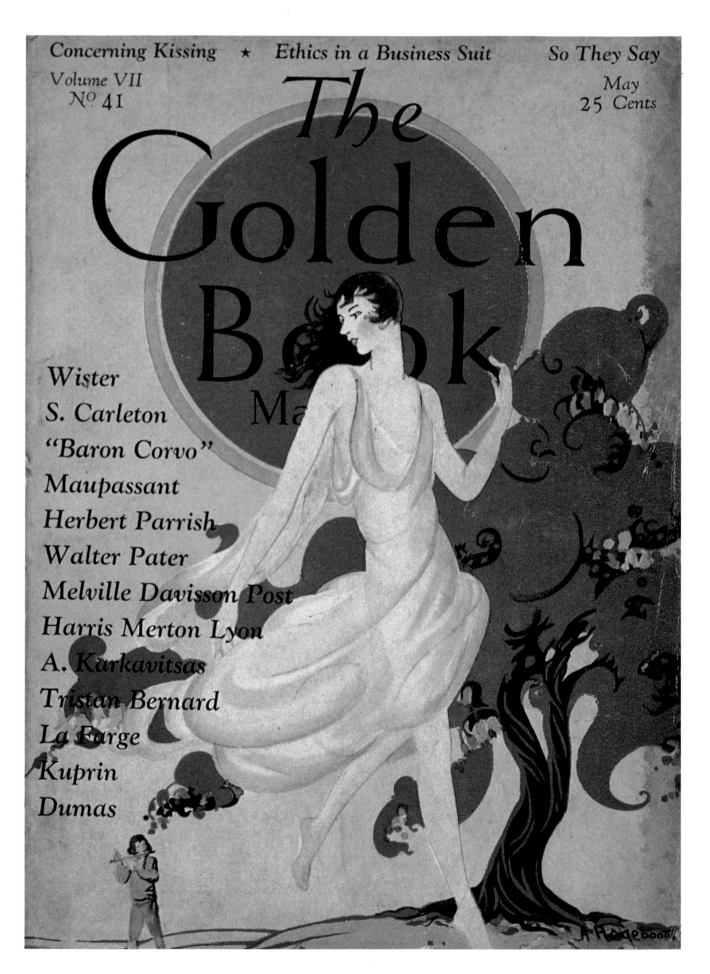

Concerning Kissing ★ Ethics in a Business Suit So They Say

Volume VII
Nº 41

May
25 Cents

The Golden Book Magazine

Wister
S. Carleton
"Baron Corvo"
Maupassant
Herbert Parrish
Walter Pater
Melville Davisson Post
Harris Merton Lyon
A. Karkavitsas
Tristan Bernard
La Farge
Kuprin
Dumas

OPPOSITE:

THE GOLDEN BOOK MAGAZINE

MAY 1928

ARTIST: AMY HOGEBOOM

At this period only the covers of the *Golden
Book* were illustrated with stylized romantic
scenes, often with a big moon or sun.

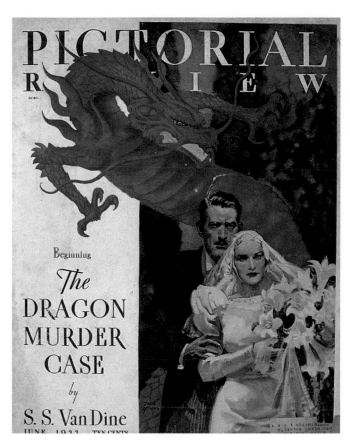

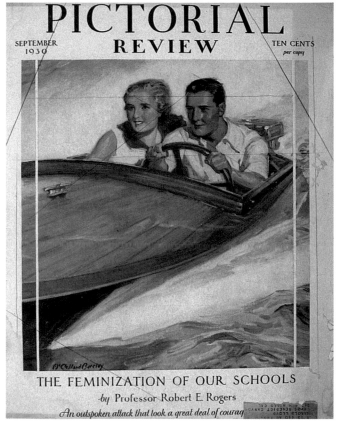

PICTORIAL REVIEW

JUNE 1933

ARTIST: CLARK AGNEW

Originally a women's magazine, *Pictorial
Review* became somewhat of a crusader and
then a more general-interest journal.

PICTORIAL REVIEW

SEPTEMBER 1930

ARTIST: MCCLELLAND BARCLAY

The cover has little to do with the provocative,
if progressive, title of this issue's lead story.

GERMANY

Berlin, September 1938
fifth year

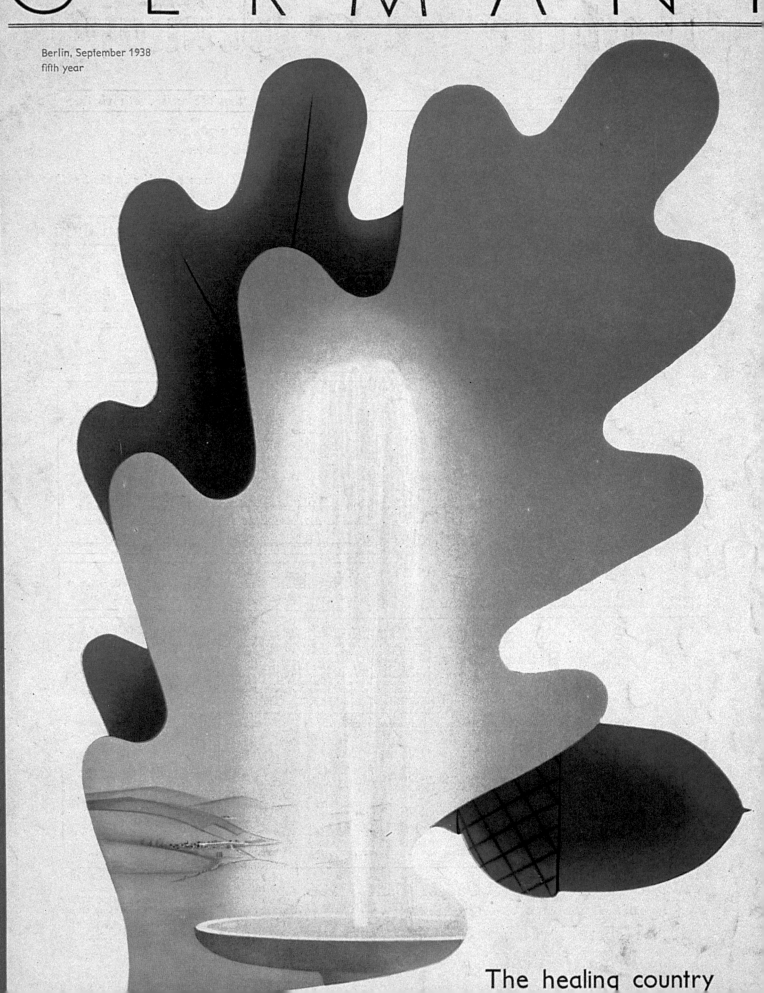

The healing country

At a time when world travel was measured in nautical miles that were expensive to traverse, the covers for travel magazines were posters for exotic places that many Americans would never see firsthand. The readers of these magazines were divided between those who lived vicariously and those who could afford the voyages. Some nations with major tourist industries published or supported magazines that enticed the world traveler. *Germany*, a sanitized pro-motional magazine, was published after the Nazis came to power; its covers were evocative of the na-tion's natural beauty, its people and history, but never revealed so much as a hint of its new national emblem, the swastika. *Nippon* was published prior to the Japanese mili-

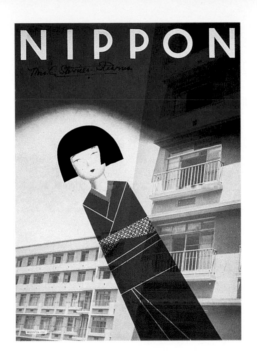

tarist ascendancy in order to give westerners a taste of the cultural riches and industrial advancement of the nation. Its covers were masterpieces of modern graphics, with designs influenced by the Bauhaus and the French *art moderne. Asia* covers, illustrated by Frank Macintosh, were quintessential *art moderne* and, rather than show the region's key locales, made icons of its cultural treasures. Homegrown travel magazines, such as *Holiday*, took their readers on imaginary treks across the globe, but were more concerned with promoting tourism in the United States. *Holiday*'s covers ran the gamut of idealized depictions of faraway des-tinations to delightful cartoons of Hollywood, New York, and Yellowstone National Park.

OPPOSITE: **GERMANY** SEPTEMBER 1938 ARTIST: LUTZ EHRENBERGER ABOVE: **NIPPON** JANUARY 1935 ARTIST: KONO

ASIA

DECEMBER
1934
PRICE
35 CENTS

OPPOSITE:

ASIA

DECEMBER 1934

ARTIST: FRANK MACINTOSH

Macintosh's exquisite art deco renderings
are arguably the most consistently beautiful
magazine covers of the 1930s.

ASIA

JANUARY 1929

ARTIST: FRANK MACINTOSH

Each cover of *Asia* focuses on a
different culture. In this *moderne*, graphics
are combined to evoke native dress.

ASIA

FEBRUARY 1935

ARTIST: ROBERT LERRER

Only a few years before hostilities pushed the world
to war, the Japanese seaman is portrayed as benign.

ASIA

SEPTEMBER 1927

ARTIST: FRANK MACINTOSH

The full sails of small vessels are a powerful
design motif in this colorful cover.

ASIA

NOVEMBER 1933

ARTIST: FRANK MACINTOSH

This cover is the epitome of exquisite
illustration. The generous use of dark negative
space is something of an innovation.

OPPOSITE:

HOLIDAY

JANUARY 1949

ARTIST: BARTOLI

This special issue devoted to Holly-
wood is distinguished by the lighthearted
representation of opening night.

NATURE MAGAZINE

NOVEMBER 1932

ARTIST: R. BRUCE HORSFALL

Is it a mask? A headdress? A Vegas
showgirl? No. It is a rare bird that invites
readers to partake of a nature journey.

AIR TRAILS

JANUARY 1939

ARTIST UNKNOWN

As the cover suggests, this is a
travelogue for the dreamer, published
on the eve of global war.

INDEX